At Work on the Garments of Refuge

Poems

Daniel Marlin and Ralph Dranow

Edited and with an Introduction
by Ralph Dranow

ROSE PRESS
Oakland, CA

Rose Press
www.rosepress.com
rosepressbooks@yahoo.com

Some of Daniel Marlin's poems that appear in this book have been previously published in: *Living in the Land of the Dead*; *Counterpunch*; *Tomcat*; *Through the Mill*; and the *San Francisco Bay Guardian*.

Some of Ralph Dranow's poems that appear in this book have been previously published in *Living in the Land of the Dead* and *Poetry Motel*.

All art by Daniel Marlin.

Typesetting and Design: Margaret Copeland, Terragrafix / www.terragrafix.com
Publisher / Publishing Consultant: Naomi Rose / www.naomirose.net

Printed in the United States of America
First printing 2020
ISBN # 978-0-9816278-0-9

For Dan Marlin

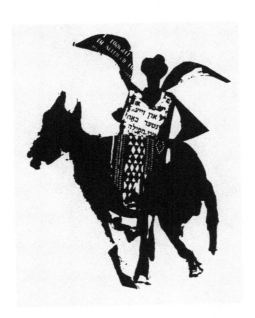

Contents

Introduction

I first met Dan Marlin in the fall of 1978, when we were both working as casual (temporary) mailhandlers at the Oakland Main Post Office. We hit it off right away, as middle-class dropouts who shared left-wing sensibilities and a passion for writing. This was the beginning of a close friendship that lasted 39 years, until Dan's death in 2017.

When I first knew him, his abundant poetic talent hadn't fully matured. Some of his early writing was imitative, whimsical and surreal, like that of his literary hero, Kenneth Patchen. Dan's early writing tended toward lush imagery; it had a wild, self-indulgent quality, like an overgrown garden, and was not always accessible. But within the next decade or so, his writing began to cohere, becoming more succinct and accessible. His 1982 chapbook, *Jerusalem on the Boardwalk,* and his 1993 post office manuscript, *Seventy Snow-Bound Pigs,* revealed his development as a poet, with many humorous, insightful, and poignant poems.

And over the years, Dan just kept getting better and better, creating a prolific body of work with tremendous power. His poems combined free-flowing lyricism, precise description (which he displayed in his beautiful artwork as well), and moral passion. He also had the gift of a wry sense of humor that frequently was self-deprecating. His poems spanned a wide range: political, nature, portraits of people, fantasy, love poems, autobiographical, philosophical, poems written in Yiddish, etc.

It has been my good fortune to have had Dan as a close friend for so many years. Along with Mitch Zeftel, we started a writing group in 1979, which is still going on, with a bunch of new faces. I was writing prose then, but when I started writing poetry in 1990, Dan became my poetry mentor. His comments on my rough early poems were encouraging and insightful. He helped me make my poems more succinct, with fresher, less prosy language.

His feedback was usually detailed and exacting, but also gently supportive. Dan was extremely helpful to the other members of the group as well. We helped him refine his poems too, I think, so it wasn't just one-sided. I owe him a great debt for his generous poetic guidance.

So it is with much satisfaction, and also humility, that I am able to repay some of that debt now by including a substantial number of his poems—and some of his artwork—in this book, along with my own poems. Our writing styles are different—his more expansive, mine more spare—but I think they will complement each other.

About my own poetry:

I'm a storyteller, and I like to write about ordinary people and the poetry and beauty of everyday life in spite of all the suffering in the world. Like a portrait photographer, I aim to capture something essential about a person in a brief moment. And to do this with compassion—and perhaps a bit of humor—because to have a human life is a glorious but also a vulnerable thing.

Dan created a large number of powerful poems in his later years—many of which have never been published before—and they deserve to be made available to his friends and fans, as well as to a larger readership. I hope these poems of his move and delight you as much as they've done for me.

—Ralph Dranow
Oakland, California

POEMS BY DANIEL MARLIN

After

After I lay me down to die,
do me no honor, name nothing and
no one after me.

No elementary school,
no syndrome of anxiety,
for I was a miserable student, fretting in
the bondage of simple equations,
hating the poisoned green of corridor walls,
and under pain of isolation
reciting the pledge twelve hundred times,
my hand upon my heart,
as if to imprint the trance of war.

Name no poetry contest
or detention center,
no hospice or place of worship—
though I will certainly die,
and I have sensed
holiness in the ballad of the morning wind,
in a thousand hidden gestures of kindness.

Name no housing project or
gated community,
no courthouse or interrogation
technique, yoga pose,
pole bean or butterfly—
not because I am humble and pure in
spirit, but because nothing beautiful
would be added to the world.

And if there was honor in my day
worth remembering, it was the river grass
that honored me, with its wind dance;
it was ladybugs, deep in the green canyon,
who alighted on the back of my hand,
as if upon a throne of comfort.
It was the beggar's blessing that redeemed me,
deserved or not, for a few cold coins
that passed between our hands.

River Riffs

The river never resisted my fingers
as I touched
the cool patience of its current—
or judged me
when I bore the city's unbearable noise
to its silent court.

Blind to all but its own
churning force, or exhausted,
inches high, and barely moving,
the river included my eyes
in its journey.

I stopped, amazed as
white nets of small Arctic gulls
settled upon its water.
I watched rutting carp
thrash their ecstatic fury of bubbles.

While pods of bottles and balls
bobbed, caught in whirlpools
at its edge, the river
labored to discharge the city's scum.

When I came to the river for succor,
it never judged my weakness.
Its colors absorbed my heart's darkness,
its midnight black reflecting
a platinum script of solstice moon.

The river taught me
to find its music
in the body I wear,
that each of its vibrating atoms—
even in grid of ice
at the roots of marsh grass—
echoes in my blood.

In the Pocket

Beside the railroad ties on the stony track,
the sleeper is outlined beneath a checkered blanket
pulled up to her ruddy cheek.
The pillow, a faded green backpack.
Afternoon fog captures the sun,
releases it in a wave. Gilman Street traffic
hard by: a steady, gleaming rage.

An old black watch cap near the sleeper's head,
and a wrinkled square of brown cardboard,
bearing a message: *Anything will help. God bless.*
Yes, you've read it a hundred times before:
pleading nailed to the city's wild door.

What God, you ask yourself, abandons the living
here at the edge? And then, as sunlight slips again
from fog's hand, an answer comes:
"God dwells in your pocket, man.
A dollar there, is currency,
however humble, of love."
So bend now, and place the money
beneath a stone's weight
under her hat, and pray that it will be
there when the sleeper wakes.

Empathy Was Light-Years Away

It was I
in a surge of wild excitement
who called the telephone operator
from my upstairs room,
and asked her to perform a sex
act which I could barely
visualize, who hung up
and was startled when
the phone rang
and my mother answered downstairs.

Expecting a
sneaky child's voice,
hearing the calm woman's one,
her own speech trembled with rage
at her switchboard:
"Do *you know what he said to me?*
Is this filth what you teach your son?!!
I should call the police right now!"

"*I'm so so sorry.*"

Ordered to descend,
I stood mute
in the court of my mother's anger.
"DID YOU?
I SAID 'DID YOU?'

You thought it would be *fun?*
FUN!

DON'T YOU EVER..............*!*
DO YOU HEAR ME?"

But as I mumbled assent,
promised never again
to violate an invisible stranger,
I could not feel the thing I'd done.

For What Has Been Given

I thank my lips
which remember
a text of stubble
on my father's sunken cheek.

My nostrils
alert to sea brine
and pine sap,

these eyelashes, which filter
floating stars of dust.

I thank the tear ducts
which allow the heart
to breach its dike,

the silken canal of intestine.
absorbing the essence of bread,

and the larynx
from which I howl,
answering *Samurai* cats
who stand stone still and electric
at the cusp of combat
beneath my window.

I thank the ear for its knowledge
of subtle threats in a voice,
kindness in a warning,

my tongue's hesitation
at the threshold
of judgment of the stranger.

Alfredo's Debt

Alfredo, a small, dark man
with broad African features,
was joking in Spanish on the front porch
with Ivan, the house manager, and his friends.
It was 1962.
A seventeen-year-old freshman,
I'd come looking for a room.

Alfredo had arrived in Berkeley
from Callao,
vaguely hoping
to wear a suit and tie
someday, make his living
at a desk.

For now, he worked off his rent
for a mattress in a corner
of the basement,
slept beneath a calendar of a mermaid
with billowing breasts.
He swept, hauled trash,
and once a week, changed sheets.

One day, he stepped out of
the room next to mine,
the bunk bed behind him stripped bare.
Pointing at the stained white linen
bunched in his hands,
he laughed.
"Hey, I see the boys get some good last night, hah?"

His expression
merry, lewd, and pained.
Then, he spoke softly.
"I want it," he said.
"I want it very bad."

A night's drinking was pocket change for
Ivan's rich friends—
but Alfredo blew a week's food money
on one round of beers;
later, was caught
taking peanut butter and hot dogs
from the refrigerator.

The manly language of sex
could not describe what Alfredo
and I wanted, but it was the language
that surrounded us
and filled us in that house.
After my brief,
incandescent love was over,
I listened for the clip clop of my lover's heels
in the wooden corridor,
heard my longing echoed
over and over
in Ray Charles' keening "Born to Lose."
I stood outside at midnight,
craning for a glimpse of her
boyfriend's red Volkswagon
as he dropped her off
down the block.

The next morning
as I left for class,
Alfredo surprised me.
"I see you out on the sidewalk last night."
He sighed,
his gaze sorrowful.
"You wait for her, hah?"

The next spring, a fire burned
through the upstairs rooms
of that white house,
scattering us.
On the street

a year or two later,
Alfredo said,
"I'm not like war so much,
you know."
He'd heard "Out of Vietnam!"
chanted in marches
down Telegraph Avenue.

"But all I get
is these busboy jobs
and my visa runnin' out,
so I'm gonna join up."

At the recruitment center
 a giant behind a gray steel desk,
whose pate was smooth as a hard-boiled egg,
offered him a Lucky Strike.
"You're gonna be illegal, son,"
he drawled, "but we can work it out.

Serve this country,
and you'll always be welcome."

His mother sent him the papers
he needed to enlist,
which didn't come cheap
at the city office in Callao,
wondering
if she'd ever see him again.

Slipping in just over the height limit
at the physical, he dropped his underwear
with a hundred strangers.
A doctor bent to inspect his balls.
Later, a corpsman pricked him with vaccinations
against jungle fevers.

Alfredo's gaze settled on
the tall reeds and cottonwoods at the Truckee River's edge,
as he traveled to boot camp
in the long vessel of a Greyhound bus.

Eight months later,
he was evacuated from a firefight in the Mekong Delta,
his brown neck bleached
with shrapnel burns.

He became a breaching whale
in the white surf
of hospital sheets in Okinawa.
He dreamed of the mermaid
behind a red-beaded curtain in Da Nang,

and of his mother
sitting on a blue chair
in front of her door.

Before dawn his spirit
dove among the ancient turtles
on their way east
through the turquoise halo of coral reefs
headed home to the gold
waters of Callao,
where at the instant
the dawn's flower
flares open the box of night,
he vanished from this world.

Dusk, Mukogawa River

I reached the river island over rocks at the shallowest
crossing and found that other pilgrims had come
before me, past dry pods of winter twigs and a grail
of pigeon tracks in the fine sand of the trail. Others
had fled the chaos of wires and stoplights to find this
place that binds the island to sky and wind, to the
shadowed ribbon of the current and the sun's red stone
descending a ladder of frost in the western sky. I found
their boot prints beside the ashes of small fires, and,
in the low rumbling of the water, silence that restored
their songs. I came to join those who take life from
this horizon: heron of deliberate step, cormorant
vanishing into the water's cavern, rocks at vigil upon
the passage of storm-broken branches.

OK for Thoreau 2014

It was OK for Thoreau
to turn to the solace of the forest,
to live lightly on the land beside Walden
Pond—but it's not OK to make your home
among fog-weathered acacia,
riprap and twisted rebar
at the old construction dump
beside the bay
in Albany, California.

It is OK to name junior high schools
after Henry David Thoreau,
to teach his book as an anthem of freedom—
but it's not OK to find your freedom
quietly, turn your back on the hustles
and holdings of the crowded
towns across the freeway.

It's OK to buy survival gear in a billion dollar industry,
motor into the wilderness on weekends,
to build campfires under the stars—
but it's not OK to bed down
to the sound of bay wind
among junk sculpture,
to scavenge iron and steel for pennies
where the iridescent green
hummingbird hovers above a purple acacia.

How Thoreau, in conscience,
defied the hype
of a war of conquest &

refusing to pay for it
landed in Concord jail
in 1846,
is most definitely OK
to teach in English 1A,
but to pay no parking tickets,
divorce lawyer, college loan,
and to pay no rent
while folk labor under mortgage yokes
in the towns across the freeway
will get you and your dog
rousted at 4 AM
by police in battle gear
who will throw you into Santa Rita jail.

Of My Peritoneal Dialysis Machine

Its tiny motherboard brain
has no code for fear or dignity,
gratitude or pity.
It does not know my name
as it fills me from five liter bags,
then drains me
through winding tubes,
bearing away
the toxins in my blood.

Its soft *ratatatat* like
the sound of a rope
whipped into a ferry's mast
on the Seto Inland Sea.

This machine
could have cleansed
the darkness of fatigue
beneath your eyes, Mother,
spared you violent
morning heaves
when the clock of your kidneys
ran down
fifty years ago.

It could have kept you alive.

Each night, its strange music:
the gentle, rhythmic crinkling,
the great sighs, like a bus braking,
the low hum, steady and dogged,
vibrating like the engine beneath my bunk

on the Black Diamond freighter
as it plowed swells of the North Atlantic.

Listen to the bag sucked dry—
its hiss of an enraged raccoon;
and to the motor grown suddenly silent—
like a hummingbird paused from its labor
at the tip of a branch.

I, who carry
your broken gene, Mother,
that falling star
in the firmament of cells,
savor, for both of us,
the luck of my resurrection by machine,
know the many
whose kidneys run down
in slums and prison shadows.

Each night I follow the
green digital commands,
attach myself to the portal,
lie down to a mechanical song,
creaking like a three day train to Merida
taking midnight curves
through the Yucatan jungle.

Home Movies

1952. My mother walks down the driveway
In the measured, elegant gait
of a high fashion model,
cigarette held at a dainty angle
away from her ear,
black hair tied in a bun,
neck rising from the lily fold
of a white blouse.

After twenty paces
she wheels around, transformed.
Brash now, clothed
in Brooklyn street smarts,
she charges forward,
hips rolling, chomping gum.
A few feet from my father
she laughs, lunges close enough
for her breath
to mist the camera lens.

When the film goes black,
the glamour and grit
of her characters
catches in the June light.

Motherless at an early age,
youngest in a tribe of sisters,
her first audience
adored her.

Performance became
a rite of celebration,

the instinct to lead with joy
in the midst of life's hardball,
as her sisters died,
one by one,
and her own body
rose against her.

In costume on New Year's Eve,
a flamenco dancer
in scarlet sash,
her castanets a pulse of wild crickets,
head thrown back,
heels striking the floor
on the beat.
After three minutes,
a deep bow
to the room's applause,
she slumps, exhausted,
in the embrace
of an old couch.

Profile

My mother doodled
while she spoke on the phone.
It was always the same sketch.

While snow fell into bare sycamores outside,
as she spoke to her sister
until they laughed or sobbed,
or until one of them
had to pee,

she'd trace
the fine, spare line
of a woman's profile,
hair styled in a short bob.

I find that sketch
sixty years later
on the inner cover of her address book,
in the blank margins
of its pages
filled with flowing script.

1929. In the Thomas Jefferson
High School yearbook,
my mother's small black and white photo
appears in a crowded grid
beside thirty others;
her pose a profile
gazing down,
dark hair in the bob
cut of the roaring twenties.

While she telephoned the plumber,
or chatted with her sister,
until the two of them
wept over lost kin,
or collapsed laughing
at their impersonations
of rich ladies in the movies,

I'd watch her fingers,
automatic, trace and retrace
the stylized nose and lips,
the elegant, ageless profile.

My Mother Forbade Me

My mother forbade me
My mother would not permit me
Under no circumstances
would my mother allow me
My mother strictly warned me against
My mother described the terrible
consequences of my
My mother told her friends and my friends
if they ever saw me
Sick as she was
my mother ran out of the house
in her bedroom slippers to grab me
before I could
My mother locked me in my room for a week
when I merely suggested

When the Time Came

When the time came
I carried my mother's coffin
through the Mayday morning
with brother shadows,
beside white poplars and a hundred
tiny sand flowers
trembling in a bay wind.

Paused before the synagogue door,
gathering light into my hollow
throat, I sought blessing
for the distance I would travel
in uneven flight, like a butterfly,
between grief and dawn.

A ritual was demanded
by ancient need,
and the shadows circled me
as I swayed, a great stone of silence
balanced upon my head,
until it fell and broke
into the starling's whistle,
the soft call of doves on phone wires.

When the time came for my
left hand to forget and my right hand
to remember
walking beside white poplars,
I followed pigeon tracks
on the soft beige trail
to the synagogue door,

where many had gathered to say farewell
to the coffin.
My brow brittle against emotion,
only a taste of salt
on the bay wind.

A Last Visit

1.
Your eyelids
are sinking now
beneath the morphine's weight,

then lifting
from short dreams
where you see
your mother waiting

2.
You call me
"Marlon Brando,"
then laugh
at your confusion

3.
You are a lover
of bitter weather

so at dawn
when the raining darkness
seems to lighten
and I say,
"It looks
like it will clear,"

you answer,
"Too bad"

4.
Soon
you will step
into the river

What matters most
as we touch
farewell

is the timbre
of welcome
in your voice

Now

Now as you begin your last journey,
I scratch the side of your canoe,
a branch of water-rooted willow.
I skim the foam of your wake, a black-headed swallow.
I settle at your breast,
a wild leaf blown out of the delta reeds.

Now that you return to our mother,
to her cycles of light and withering,
sail away from our table of stories,
their silly, raucous and tender rites.
Now that you vanish from the circle of voices,
I swim beside you, a small river otter.
I cling to your shoulder, a monarch,
folded wings at rest in the wind.

Now, as the river leads you to its mouth,
with your cargo of heartbreak and delight,
I dive beneath the salt channel,
surface among shreds of kelp,
where you reach the abyss
of the open sea.

Thursday Ritual 1959

Moskowitz came first,
in a long camel's hair coat,
fingering his silver curls.

Cord arrived next, a pipe
glued to his lips,
then Silver, skinny and overdressed.
Like my father,
they'd risen from humble roots
to this verdant suburb,
where everyone ,
except the maid,
was white; divorce was rare,
offspring went to college,
and a man's worth was on display
in the contour of his Cadillac fins.

As seven o'clock approached,
my mother and I retreated
before the oncoming storm.

The dining room table was set
in vivid casino green;
ashtrays arranged,
playing cards unpacked.

Slowly, after the first hand
was dealt, as smoke
began to rise in slow, curling fountains,
the contest of insults began.

"Moron!
You never saw a jack of hearts before?"
Screech of the lawyer who spoke calmly
all week above his bowtie.

"Putz!"
Hiss of the one with flushed, bald pate
who spent his days
dickering over bolts of fabric
for ladies' blouses...

"How many times can one human being
make the same dumb mistake?
I pity your mother!
I pity your wife!
I pity your wife's mother!"

The one under attack
had yelled at his secretary
all afternoon,
but was strangely silent now,
like a child cowering
before a third grade teacher.

In this perverse sportsmanship
of the tongue,
in this ritual slaughter of dignity,
the week's hustle-
guilt for affairs with other women,
kids talking back,
bad investments—
was washed clean
in the blood of the lamb of disdain.

When they were done
with each other,
flecks of gray cigarette ash
scattered across the jade firmament
of the table,
they threw their cards down a final time,
like dirty rags,
stood up, with strange, weary relief.

"See ya in a week.
Bring your brain along next time!"

Back Where You Came From

In March 2012, Shaima Alwadi,
A 32-year-old Iraqi immigrant to
El Cajon, California, received an anonymous note
which read," Go back where you came from."
A week later she was found murdered
On her living room floor.

You hiss," Go back where you came from,"
to people who do not look
like you.

Let's say you took your own advice,
and went back
where you came from
to the tubercular slums of Glascow
a hundred and fifty years ago,

or the peat farms of starving Galway.

Or to Moledetchna,
where Jewish boys
changed their names to avoid
twenty year hitches
in the Czar's infantry,

or to Reggio Calabria
when landowners
had their way with peasant girls,
as they worked the girls' parents
into dry furrows.

Try going back, not as a tourist
with credit card, but clueless,
in the humble shawls
your forbears wore,
gathering lice in storage.

Before they poured off the docks
to have their names
butchered at the recording desk
by the immigration officer
checking for signs of palsy,
scanning the list of anarchists.

Sail backward
past ports of departure,
through centuries as soldiers,
hiding your religion
or killing for it,
as wet nurses,
unable to feed your own.

Back through the winters of Rhineland,
Bohemia, Piedmonte,
along trails of forgotten migration,
from the millennial ladder
to ancient African valleys
where your great mothers
learned to walk upright.

But don't stop there.
Forage with pointed snout
for grubs among ferns,
beneath the shadows of Pterodactyls.

Re-enter the primal ocean,
before our fins became toes,
and our lungs began
their subtle duty.

Become again
the one-celled flares of life
we were

and continue—

into elemental stardust,
the whirlwind of the black
invisible hand.

Of My Chopping Board

Its nature is silence.
It does not answer my reverie
as I stand above it and chop.

Each slice through moist
acrid layers of onion,
zucchini's glistening heart
leaves another faint scar
in its blond wood,
a cipher among thousands.

Its grain is yielding. The knife finds traction;
firm, it does not trap the blade.

On a night of love's expectation,
it was my witness,
as I cut wild white hairs from the scallion's root,
listening to a violin's song
float out of the radio
into my bones, an angel of longing.

When grief was my companion,
tears fell into its web of tiny cracks.

I have seen Pauwlonia trees,
like the one from which
its wood was culled;
their fluted purple flowers
shiver in the mountains of Shikoku.

Scrubbed again and again, its pores washed clean,
restored to its useful innocence,

it remains an almanac of flavor and debris:
clear bitter drops of lime,
pink watermelon meat,
the pale vein work in green chard leaf,
of harvests that have nourished me.

It was born of the forest,
and grew in silence.
It does not answer me
as I stand above it and chop.

Okinawa

A mild sea breeze combs Naha City.
Crimson bougainvillea,
wild and spidery, wave between
cement walls.

The airport bus
stops at a bright downtown plaza
where a class of small children,
in short sleeves and beanies,
bounce in a great pile of
slowly melting snow—
a play gift from the North.

At the wharf up the road,
teenagers on their skateboards
are daring gravity,
with a leap from stone stairs.

Two fighter jets
corkscrew and bank in tandem,
silver flash above the white ferries in harbor.
A roar unfurls behind them,
like a torn cloud.

Peace Museum

The museum faces the tip of the peninsula,
site of a last, catastrophic battle, June 1945.
Steep jungle cliffs descend to ocean calm
where the emperor's soldiers
jumped through smoke and fire.
Death before surrender.

There's an orderly cemetery now,
each tomb imprinted with a different
nation's flag.
An old woman slowly
rises from her prayers before a gravestone,
leaving an offering
of unopened beer can and a single lavender flower
on its ledge.

Okinawa island kingdom, ringed by coral and turquoise,
its songs riding the wind.
Conquered first by the lords of Kyushu.
Again by American fire.

After the war America stayed,
its bases pushing out tombs and orchards.
From air strips built into cane fields
B52s crossed the South China Sea
to burn the jungle canopies of Vietnam.

Today, through safe, gentle sunlight,
profiles of marines
pass in camouflage tanks.
Some will ship out to dun-colored streets
where minarets call to prayer
before daybreak.
Some, like their fathers,
will learn to shoot
anything that moves.

But more than them, it is us.
Without us, war cannot live.

Like the wind we share, tooled through our lungs,
cleansed by leaves of island pine and bamboo;
like the wind, war connects us.

Like the water we share,
upon which our blood depends,
water cleansed by the marsh grass of inlets;
like water, war connects us.

Like the horizon we share,
compass to our wandering,

and the night,
where the million cells of our eyes
are cleansed in the arc of sleep,
restoring their art;
like the night, war connects us.

The Ride Back to Town

Finished with the grim dioramas
Of the museum,
the hand-written sorrow of survivors,
grainy films which trace
decades of occupation,

we wait at a bus stop outside,
where a cabbie offers a bargain fare back to town.

He talks fast
of his son's sluggish path to marriage,
the cherry blossoms' early tropical bloom.
His cell phone sings: "Amazing Grace"—
a call from wife
with shopping list.

He chortles. "She's got to have
the ice cream fix."

Catching Toshiko's eyes
In the rearview mirror,
he asks if her middle-aged,
foreign husband,
with his *No War in Iraq* badge,
is a "military man."

I flinch.

He looks back at me, asks,
warmly,
"Tasted our beer yet?"
"I don't drink."
"It's delicious!
Nothing like it! Everyone loves it!"

"How about Okinawan food?
Fried pork soup *soba* yet?"
"I'm sure it's great,
but...."

"Chicken, fish, beef?"
"I'm a vegetarian."
"A what?"
"I don't eat any animals."
I glimpse a moment's
incredulous pity in his gaze.
We arrive.
"OK, your hotel
is right around the corner."

Procession

Berkeley, California

When the flock stops traffic
on Gilman Street,
there are no horn blasts or curses.
Stalled drivers
unhitch seat belts,
aim cell phone cameras
at the loping procession,
wait.
Sixteen wild turkeys cross.

In the middle of the road,
a tall tom stops,
unfurls a great banded fan
of rust-brown tail feathers.
Crimson wattles ballooning,
he rotates a slow dance,
dragging wings
in full circle
so that all
can take the measure
of his splendor.

The hens, restless,
have seen it all before.
They mark time,
pecking at infertile asphalt,

until, ritual done,
they ripple onto the sidewalk,
resume their forage down the road,

beneath train tracks,
in and out of dry grass,
among tender shoots and grubs,
moving north
through long shadows
gathering to dusk.

On This Planet

You were Mitchell Zeftel
on this planet.
You're free to recall that name now,
to caress it like a small turquoise stone.
Or, you may throw it
into the whirling tide,
and forget everyone you knew.

Your brain, its web of magnetic antennae,
has made a slow pilgrimage
for three years
into the soil of Colma cemetery,
among star pebbles and scattered shells.

Standing above turned earth,
a rabbi prayed at your grave
to a God you'd teased, forgiven,
for whose anguish you wept.

Mitchell Zeftel.
It is the name that appeared
on your PhD thesis,
*Disaffected selves—symbolic
interaction in suicide, madness
and bohemianism,*
and on your Weekend Special tickets
to Reno's blackjack tables
and free finger food.
Once, outside your door on Alice Street,
a night hunter shoved you
as he reached for your wallet.

Your cane flew out of your grip.
The pavement ripped the flesh of your hand
as you fell.
You cried out, and he ran, breathing hard.

There is no street crime in heaven,
or is there?

As Mitchell Zeftel,
you suffered disappointments.
Yet failing to become a professor,
you made a profession of dreaming
at cafe tables,
where you voyaged to other worlds,
recording the taste of pastries
in outer space
upon a long menu of poems.

It is true that your grip
grew clumsy
as your cataracts darkened,
that reaching for a can of Doctor Pepper,
you knocked its foam onto your thigh.
Now, your fingers are nimble
as a sparrow in a blackberry thicket—
that is, if green vines bear fruit in heaven.

Mitchell Zeftel
was the name on Ward E-5
medication slips.
At times, you wanted to throw that name
into the foggy night,
along with a thousand paper cups of apple juice.

And yet, as Mitchell Zeftel,
a peculiar grace
hovered above your shoulder,
in your smile,
infused the warmth of your thick, chapped hands
as you squeezed ours in friendship.

When you roamed the streets,
harried by a demon chorus
inside your head,
and were turned away
at the gates of respectable lodgings
because of your swollen feet
and slept-in coat,
you found a path to a rough hotel
with a fortress door,
where no questions were asked
and no one judged.
And when you sat dreaming in your tiny room,
day after day,
scattering the crumbs of crackers
as you filled notebooks
with wild fables,
brother mice arrived.
And when these brought you
fever of pneumonia,
and you did not rise from your bed for days,
or answer knocks,
someone unlocked your door
so that you were not left to die.

Your mother arrived
from far away

to rescue you,
and you bent your head to her shoulder.

In the years that followed,
you were grateful
to have survived your voyage,
making port in the soft,
no-exit harbor
of Laguna Honda Hospital;
grateful for a gift of take-out
Blondie's pizza,
defying the bland diabetic tray;
and for Stravinsky's *Firebird*
streaming into your headphones.

When you went completely blind,
scribes came to sit beside your wheelchair
in plastic chairs, with notepads,
recording your stories and poems
in labored and looping scripts,
so that your words
could enter our alphabet,
hilarious and poignant.

You were Mitchell Zeftel on this planet.
You're free to recall that name now,
to caress it like a small turquoise stone.
Or, you may throw it
into the whirling tide.

West MacArthur Guard

Sole guardian of wrenches, hoses,
And BMWs tagged for repair,
She's trained to repel the stranger
Whose scent she does not know

Boundaries of her duty are
Steel fence, cement walls, a floor
Stained with twenty years of engine grease

At midnight she inhales a sharp
Stream of marijuana smoke
Drifting in from the sidewalk
And on warm evenings the tang
Of fennel seeps down
The embankment to the
Sleepless freeway overhead

At the window of a morning bus
Stopped for red
I see her emerge, sleek and tawny,
Square pit jowls,
And face a tall bearded
Man standing at the fence
With his bicycle

She moves toward him
In tight confrontation
When the fierce light of her gaze
Gives way,
Like a slipknot,
To an instant's recognition—a timbre of kindness

In his voice,
Calling her out of her bunker of shadows

Her tense haunches yield
To a faint wiggle of celebration
As she approaches him
While the bus pulls away

Chase

As a young mammal
I loved to be chased
into summer dusk.
In games of hunter
and prey we fled each other,
froze, held our silence
to avoid capture,
vanished.

I did not expect, fifty years later,
striding down the slope of Josephine Street,
that three boys of eight or nine
lingering on the sidewalk ahead
would catch my eye,
shy but hopeful, or that one
would ask, "Mister,
would you chase us?"

"Are you sure,"
I asked,
gathering a monster force,
"you want me to?"

"Yeah, yeah,
we *want* to be chased!"

"One, two, Yahhhhhhhhhhh!"
My cry scattered them,
like starlings
at a freight train's roar—
down the driveway—
turning at the green and ash—

colored garbage cans, while
fast behind I
grab a flapping
blue T-shirt, raising
hilarious screams
from the boy who suddenly pivots away,
darts a narrow channel
between blackberry vines
and old garage brick,
leaps out of sight—
where I leave him
to savor the end of the chase.

Uranium's Song

I lay hidden beneath alkaline dust,
the pink and copper oxides
of canyon walls
where mountains rise
from the desert river.

Neither blessed nor cursed,
I dwelled in silence.

Life never entered me,
like saguaro or antelope
whose hooves strike the hard hot earth,
or like the turquoise lizard
of long, still meditation.

I drift now, a tiny genii of chaos,
released into clouds
and green tides that cross the Pacific,
tainted by the burst spleen
of Fukushima Dai-Ichi.

In sandstorms once,
I whirled through Baghdad
after the smoke of tank shells
bled into blue haze.

I entered the lungs
of the women of Fallujah,
whose children were born
with hideous cavities,
and I found my way
to the ewe's womb

beside the Tigris,
where she gave birth
to two-headed lambs.

Long ago,
I entered the marrow of Hiroshima;
sang my song of plunder
in the bones of Nagasaki,
scorching them from within.

I've taken many lives,
but I never lived
like ravens
or slim cedar, whose leaves
are coated now
with my signature,
in the mountains
of Niigata and Toshigi.

I did not choose
to become an Angel of Death.
Before you came
to dig me from my place,
I dwelled in silence,
among sage and yucca,
beneath the red evening wind.

Cold Beauty

Shikoku pilgrimage trail

We are enfolded in the Buddha's hand:
heron, paddy frog, pilgrim, dragonfly.
The trail leads in and out of the world;
first a mountain path, then a raucous highway
littered with shreds of big rig tire.
Death leads us slowly
out of our days,
or stuns by collision.

The long pale cat
in the middle of the road
feels nothing now. One pointed ear
smashed crimson; its gaze
frozen beyond pain or rescue.
There is no life to save,
but I cannot abandon
its form.

Wait for a pause in traffic,
quickly lift its cold weight
from the path
of a thousand wheels
before it is butchered again;
lay its cold beauty
in high grass at the verge,
where the slow feasting
of ant and raven
will begin.

Opossum Before Dawn

In frozen sleep
it straddled the turn lane's white arrow;
hind feet demurely crossed
in mid-stride,
narrow pincer snout
parted at the lip
to thin pink gum
and sharp crooked teeth.

It woke at moonrise
to prowl a landscape
of signals and odors,
feed upon fallen berries,
dead bees;
sniff, within their slick paper sheaths,
half-eaten breads.

I glance down the road's black distance
to tiny green eyes
of distant stoplights,
a white cluster of headlights
faintly advancing.
There is time
to honor the unwritten covenant,
lift this opossum's
gray furred weight
by its hairless, onion-skin tail,
and lay it down
at the curb.

I Was Columbus

1952

Alice Shapiro,
playing the native,
knelt before me,
a hawk feather
rising from her blond curls.

Cotton mustache and goatee
taped to the smooth skin of my face,
in a cloak of blue crepe paper,
I raised my hand in blessing.

My saber was
cut from cardboard,
painted silver.
Though agile in duels,
having run my brother through
a hundred times
with paper sword
as we battled
up and down the staircase,

that day, before our third grade class,
I was austere, benign;
my weapon,
borne with restraint,
a wand of silent power.

Truth, alas, had no role
in the performance.

What did we know
of the cold lust
at the heart of the voyage?
How the Spanish admiral
was welcomed on green Guanahani island
with gifts of cassava, parrots, balls of cotton;
how he kidnapped his hosts
at sword point,
demanding they lead him
to fields of gold;
how quickly he ravaged their world?

Four hundred and sixty years after
he made landfall,
I was proud
to be Columbus.

Under Suspicion, Berkeley

His shopping cart
is wedged into a niche in the
wall behind him,
its great pile
seeping under a worn blue tarp—
with the soft stuff
that fills basements and garages.

He's a slight man
with copper skin,
leaning forward
in a gray T-shirt,
strands of long black hair
falling over his eyes.
He flexes shoulders
and elbows, down to the handcuffs
cinched at the small of his back.

What's your name?

the officer asks, and
bends to listen.

Spell it.

With fingers gloved in lavender plastic,
he scribbles on a notepad,
shows what he's written.

Is that right?

The small man's reply is very soft,
as if he's been jerked
out of long hibernation,
or a dream where there is no speech.

You have an ID card?

I can't hear you—

Did you lose it?

Date of birth?

Ever been arrested?

The officer
searches his pockets,
pulls out a dirty handkerchief,
but no joint, knife or money.
The man's pants slip down,
revealing spotted purple underwear.
The officer yanks them up,
by the belt.

There are three cops surrounding
him now.
One turns
to my silent witness,
asks, flatly,
"Can I help you?"

"No, I'm just standing here."

Another is on the phone to headquarters
as the suspect's name

is run through the gauntlet
of a distant computer.

Finally, pointing at the cart, the officer warns,

You need to do
something about that pile;
you've got to take it down,

as he removes the cuffs.

The man wriggles his wrists and fingers,
and turns toward his possessions,
trance-like.

Home Depot Parking Lot,
Richmond, California

Crossing the parking lot's vast field,
I'm stopped
by a sweet, electric chatter,
turn to a bare buckeye tree
on a cement island,
its branches filled with blackbirds,
perched fast against the damp morning wind.
They've made the stout copse
a bell of wild, bright whistles
rising above the noise of truck engines
and slamming car doors.

Beneath the tree, birds
dive into a puddle,
hop about, shake drops from their wings.
One, very black, with scarlet stripe at shoulder,
glides to land in the loud
milling congregation—
which is oblivious
to the stream of walkers
passing a few feet away
toward the great glass gates
of Home Depot.

Perhaps, before this meadow
was blackened with asphalt
and the crumbs of nacho chips,
beads of fast food grease
became their daily fare,
the flock's ancestors

foraged for seeds and grubs,
at the edge of bay marshes.
Perhaps, some ancient intuition
roots them here,
where they heed
the clock of dawn and darkness.

On a curb near the store's entrance,
another gathering, of thirty men,
also sundered from their native ground.
Standing alone, or chatting quietly,
shoulders hunched against the chill
in gray and black sweatshirts,
their buff boots made to withstand
the mud of ditches.

They've reached
Richmond from farms ploughed under,
distant villages where work is scarce;
having left children behind,
children who smile, now,
on their cell phone screens.
The men are waiting
for a car to slide by,
lower its window,
offer a day's work with a shovel or rake.
Their perch is fragile,
vigilant at the edge of San Pablo Avenue,
for we are north of the border,
and the ice hawk circles somewhere,
to appear without warning.

How to Tell Grandma You Love Her

Knee-high to the bored, patient giants
in the long, winding queue
at the hospital pharmacy,
he darts between legs,
deft jester, in baby blue T-shirt,
corn rows.

A middle-aged woman
in an indigo shawl
calls, "Marcus,"
and he appears,
meets her gaze
with a daring glance,
scurries away.

When he returns,
she's speaking softly
into her cellphone.
He reaches up,
hungry for its magic.

"Say goodbye to Grandma,"
she says,
and hands him the receiver.

"Abi mama mami abi abi poolah...,"
he babbles in
his own spirited tongue.
When she adds,
"Tell Grandma you love her,"
he chatters on, wild and earnest—

then stops,
thinking light
entering his eyes.

Lifting the phone to his lips,
he smiles and kisses it,
again and again.

Kisses Grandma inside.

Statue of Endurance

He'd made that corner his own,
for three years, a barely moving
statue of endurance,
bedding down in a doorway,
taking what the weather gave
in green poncho
draped to his ankles in winter rain.

Porkpie hat, gray-blond beard,
six feet and big-boned,
he was clothed in solitude,
a brother to migrating clouds,
to changing light on storefront glass
as he ambled across Shattuck Avenue
to buy his pack of Camels.

He met my eyes with deep quiet,
rooted in patience,
or resignation, and something more
I could not name.
Returned a greeting
but had no chitchat to spare.

With money, he would have eaten in private,
away from the restaurant of the wind.

I wondered where he'd been
before his vigil
on this outpost of concrete?
Did he gamble a house away,
or losing his job,
watch the bank build a fence around it?

Did he feed hummingbirds?
Come upon giant sequoia,
rising from the altars of mist?
Do hard time
behind bars,
or an office desk?
Dodge shrapnel
in war's long tunnel
of memory?

His absence was sudden.
A heart attack, said the panhandler
in front of the shoe store
up the street,
who'd watched the red
ambulance drive him away.

Maybe, descended from his corner cross,
the big, silent man
found resurrection
in the arms of a social worker,
who found a way
for him to live.

I came upon him from behind
one warm summer noon,
his great back shirtless,
spotted with whorls of bleached skin;
he was collapsed, it seemed, into his
shopping cart.
Passing him, though, I saw he was alert,
pencil in hand ,
bent over a Sudoku puzzle,
pondering its subtle,
hidden clues.

Dream of a Haircut

In my dream
my father wants to cut my hair
for the first time in my life.
I've never even
seen him hold a scissors.

How will he do it,
with his trembling Parkinson's hands,
which dart above his chest
as he lies in bed
passing through dream storms?

How will he hold the razor,
when he can no longer grip a spoon,
or ask,
"A little shorter, maybe?
The sideburns?"
now that his voice is barely a whisper,
tangled in the frozen
cave of his throat?

How will he lift the small mirror
so that I can view the back of my head
in the wide looking glass
above the counter, where his license,
embossed in bold type,

is taped to a corner:
George Marlin, Certified Father?

Fox

Fox did not expect me
On the foggy hill
At dawn

Surprised he stared long and long

From his rust and silver face

Until he turned, slow and calm,
And into scrub was gone

For fox did not expect me
On the foggy hill
At dawn

Sleeping with the Enemy

Our fathers never met on the battlefield.
Yours had a weak stomach
and was sent home by the Imperial Army
to his many children
and rice fields in Shikoku.
In the middle of the war,
he helped widows
of neighborhood men
by midwifing calves
in their barns.

My father walked with a limp—
and since soldiers must run,
he too was sent home,
to his city office in Brooklyn.
Winter nights,
he patrolled the beach
at the end of our street, with neighbors.
They waved flashlights toward the onyx sea,
looking for Nazi subs.

You and I have lain
with each other's trust
for many years,
but I learned to fear your kind
as a child, saw no one
who looked like you
except at Chinese restaurants
where Dad showed off
for his cringing family,

"Gimme some flied lice."
He'd place his order,
as the waiter's face
turned to blunt stone.

Meal over, he'd drop a big tip.

❧

The war was history by 1951,
but the thrill of its violence
sold breakfast cereal and detergent
on daytime television.
I watched sea battles
over and over, in which
torpedoes crossed the water
for a few seconds of suspense
before the enemy ship
imploded in a fireball
to a crescendo of Mahler strings.

Jap Kamikazes, mad waves of diving crows
plunged into Navy flight decks,
black billows rising from the carnage.

It was not surprising, then,
that one summer night by a vacation lake
at the house of my parents' friends,
I was stunned by the fact
of an Asian housekeeper
who introduced himself
as "Charles"
as he entered the room
I shared with my brother

and made our bunkbeds
before we slept.

Or that I awoke at midnight,
screaming, from a dream
in which Charles had snuck up to my bunk,
his long Jap knife
about to slit my throat.

The Death of a Field

Mukonoso, Japan

The first hint is a taut red surveyor's string,
tied from bamboo pole to pole,
across the small, ochre field.
Then, a soda can tossed into its winter furrow
and left to rust among thorn grass.

A sure sign
it's been sold
is the absence of the old farmer,
who came each day
for twenty years
to weed and tidy.

One by one, the fields of Mukonoso
are laid with asphalt, and
the white, numbered grid of
parking spaces.

The backhoe will soon arrive
to churn up this soil,
which is seeded with larvae.

Moist summer nights,
the feverish chorus of paddy frogs
roared—then went abruptly silent
as human footsteps came near.

Here, I saw the sky reflected
in the wet paddy's
silver mirror at noon,

and at dusk
the faint shape of a heron, in hunter's
vigil, above the rippling snails
at its feet.

Here, I leave a green gift behind.

What It Feels Like

A college drop-out
in a small Berkeley room,
determined to evade
the war I hated,
I filled notebooks
with poems
in the manner
of Garcia Lorca,
laced with ecstasy and rage.

When I heard that the woman I desired,
who had not answered
even one of my love letters
for months,
was a student
at Merritt College,
on Old Grove Street nearby,
I went there,
hoping to see her face.

Merritt was the cradle
of the Black Panther Party in 1965.
As I opened the glass door
to a busy corridor,
a young man my age
was about to exit
from the other side.
I held the door open for him.

Passing me,
he stopped for a moment,

met my eyes,
said,
"Thank you.........*boy*,"
his quick smile
savoring my wounded surprise.

Later, I imagined
his bragging rights:
"You should have seen that cracker's face!"
and a round of laughter
answering him.

I walked home
from Merritt College
without laying eyes
on the one I desired.
Instead, for an instant,
I'd become

virtually black,
force-fed
the white man's trash.

Tempted to believe,

but not quite convinced,
that I'd deserved it.

The High Court in Jerusalem

West Bank

The court appears a dance
of manners, where the violated
man, for whom his land is life,
can petition for the right
to let his orchards stand,

while the counter claim, of violent taking,
roots itself, a spreading vine,
becomes a fortress wall,
divides the village from its leaves
of zatar, mint and thyme.

Wells diverted, cactus gouged.
The hill's dry shoulder broken.
The lamb's bell caught
in beards of wire.
Olive bark set afire.

As the colony is built
where orchard stumps
are cleared,
the court itself becomes a goat
that slowly chews the years.

Blackbirds peck in fields unsown;
the plaintiff's rage turns to stone.

To Be Human

Forgive me not,
the Angel begged.
I've brought you no loaves
of bread,
no honey, not even a single
soul.

My shoes have turned to
dust,
my hat to sand,
the heaven gold in my pocket
is become but ash
in the wind,
and my wings
melted
in one small glance
of your sun!

Good,
answered God—
now you know, perhaps
a little,
what it means
to be
human.

Pantoum

The sicker you get, the more it cost
Could you spare me sixty cent till Friday?
I had five bucks on the Goddamn Giants, and they lost!
Sometimes I want to leave here, sometimes I want to stay

Could you spare me sixty cent till Friday?
Girl, I'm sick of candy, but thank you, that's sweet
Sometimes I got to leave here; then I know I got to stay
Foreman be cold, but he can't take no heat

Girl, I'm sick of candy, but thank you, that's sweet
You see any dollies outside, Jack?
Foreman will be cold, but she can't take no heat
Sunday may be righteous, but Monday's stone fact

You see any dollies yonder, Jack?
Who you like for All-Stars, third base?
Sunday may be born-again, but Monday's stone fact
The reason I walk slow? Cause I ain't in no race!

Who you like for All-Stars, third base?
I had five bucks on the ass-whup Giants, and they lost!
The reason I walk slow? Cause I ain't in no race!
The sicker you get, the more it cost

Norman

Norman seems a playmate
in summer T-shirt
eager for a game,
not no man
in polyester and deodorant
sixteen months from pension
in the artificial tropics
of the second floor,
crossing to the dull circle of our labor,
one arm stiff at his side,
the other grasping a clipboard
like a discus
in the crisp, wide rhythm
of a military stride.
At the baseline
he tosses a word-ball
into our court:
"Peotomy!" he barks,
and confident, watches
as we scramble for possession
groping after its spin, till defeat
shames our eyes.
The word arcs smoothly, *swish*, back
into his mouth,
and out pops its meaning in proud, dictionary prose:
"Peotomy: surgical removal of the penis"—
then quick, stealing the ball
on the rebound, he shoots, "Metromaniac!"
and we leap to block another basket,
but helpless,
see his perfect aim pierce the hoop

of our ignorance
and score again, "Metromaniac: one afflicted with the
mania for writing verses."

Triumphant, expansive, he raises his clipboard
and nods to the tic tac toe grid
of a puzzle he prepares for the post office rag,
"I'll make it like this—use state capitols,
birds—easy, you know, but I won't
use *intimate* and *instigate* interchangeably
like so many after-dinner speakers—
throw in *piscular*, maybe, *karezzi*—
make them scratch their heads."

In another man, these swollen
purplish veins at the base of the nose
may suggest overindulgence,
but Norman has been "born again"
and drink is not his weakness.
Though his stride speaks precision,
bending over his crossword
or the *Seven Steps to Christ*,
he is a monarch of chaos
without time to make clear
vague, hazardous work floor orders,
a tyrant who, annoyed,
repels the questioner
with impatient snarls.

The small red book he lays in your hand
from a distance resembles Chairman Mao's quotations.
It is, though, quite a different bible,
Dictionary of Difficult Words,

with which to gild the space
between graveyard and swing shifts,
to sound out the hours with useless and elegant verbs,
to name and describe extinct tortoises and stars.
"Take it home and read it," he says. "You'll learn
something."

Norman seems a playmate
eager for a game
not no brown nose
who'll turn on you quick
after a day of absence,
a single day after ten days on,
a single day after two weeks of ten-hour days,
slapping a paper into your hand,
warning you against weakness.
After a second sickness
it says
the penalty is separation
Old French from Latin: *separatio*
a separating, from *separatus*, past participle
of *separare*, to separate:

1. the act of separating
or the state of being separated
2. the place where a separating occurs,
to break a division
3. something
that separates

Work Gloves, Post Office Issue, Extra Large

This leather,
dyed and stitched
to cover my hands
against sharp box corners,
sacks of rough canvas,
padded a young steer's haunch once,
was tight at his shins
as he waded creeks,
brushed wild thorns,
a detail in the prairie.
When he huddled in shade pools
beneath wide summer oaks,
and when he trampled rime frost,
bellowing into the winter mist
until he was answered,
this skin moved
upon the warm scaffold of his bones.
In transport
it was rubbed raw
against the flanks of others,
wedged into sudden squalor
of the yard,
stretched and torn
as he hung from the moving belt,
chained to a broken leg
while terror and pain
made his eyes huge
till a knife relieved him of his voice
and he was, at last,
made useful.

"If You Are, If You Ain't"

Teebow was dressed to party
in a silky orange shirt
and worked bare-handed
to callous the skin
of his fingers to steel,
to Kung Fu hatchets

The day before
he called me a cop
a rainbow rose
beyond the bus, at the cold edge
of the Oakland port,
and later, at work, the wind
fluttered pastel tags
on man-high cages
full of mail

Teebow, in the distance,
raised a huge sack over his head
like a rag doll,
and tossed it away

❧

Mornings
Teebow'd welcomed me,
offering his warm hand often,
leading mine
through the slipping changes
of a soul shake

I saw him now
lift a smaller parcel
in a lay-up drive
over the rim of the Martinez cage,
then whirl to deliver
two karate chops
to thin air, smile, shrug his shoulders, and
step down from the platform
to stride slowly,
in a regal, measured gait
to the stairwell door
and a little unofficial
"R & R"

A pair of sparrows flew in
from the truck yard,
agile between masses of steel and cement

❧

The day before
he called me a cop
I asked Teebow—

How much time did you do in the army?

How many kids do you have?

—but the army
wasn't the only time
he'd done,
and the months for drunk-driving
in county jail,
and the rest of his thirty-three years

had make him fear and hate the law,
and though my grandpa
was a sweatshop-busting
union man,
and my poems
shone with solidarity,
when the rumor reached Teebow that the hippy
was a narc,
it took root
in his mind,
for he had a few things to hide

The next day,
through the rasp and roar
of the platform,
I could not make out what he said
as he joined me,
I thought,
to help

My eyes wandered
across another silken shirt,
lavender and gray,
wondering,
were those gondolas or castles
repeated
from his waist
to his collar

It was his finger,
rigid with anger,
which shook me
out of my dream;

a long, long-nailed finger
jabbed in rhythm
before my face

"You ain't,"
he jabbed,
"You ain't got nothin',
nothin' on me!

"You been askin',"
jab-jab,
"askin' too many questions on me!"

It was me,
waking slowly
to his meaning,
who used the word "cop"

"You think,"
I said,
"You think I'm a
think I'm
a cop?"

"Time
will tell
if you are,
if you ain't!"

You Look Like Jesus

You look like Jesus, Marlin,
Like the one on my grandmother's wall.
No offense, now, beg your pardon,
But you do look like Jesus, Marlin,
Half-asleep and half-starvin',
With that hair and beard and all—
You look just like Jesus, Marlin,
Like the one on my grandmother's wall.

Lord Wild

O where hae ye been Lord Wild my son?
O where hae ye been sa hard and sa stout?
I hae been to the locker room, mither; give me my time card
For I'm weary and wrathful and fain would punch out

What gat ye to your dinner Lord Wild my son?
Your mouth it doth reek, say did ye choke?
I drank dinner from a paper cup, mither; give me my time card
For the hour is nigh and the day is a yoke

Who gat yet to your dinner Lord Wild my son?
With your shirt sa pretty and your eyes sa red?
'Twas a tall man with bad knees, mither; give me my time card
For I'm a dyin' bored, and the day's nearly dead

And where are your grey gloves Lord Wild my son?
With the letters of your name writ thereon?
I kicked them like they was dogs, mither; give me my time card
For I'm weary with barking and fain would get gone

O I fear ye are drunk Lord Wild my son!
O I fear ye are high as the midnight moon!
O yes! I am drunk, mither; give me my time card
For I'm weary with hunting and fain would lie down

Gospel Silence

I sit within hand-written walls of a restroom stall. The outer door swings open, and in from the work floor a bone-sweet falsetto arrives. "Lord, keep my soul!" It soars above the sound of body water targeting the smooth urinal lake, then the hard, sudden tide of the flush. The singer's heels scrape over the floor's tile grid, to the sink. "You are the only!" the hymn resumes, but is lost in a hiss of faucet, and the dull snap of paper towels pulled from the dispenser. "No one!" A swell of longing, arc and beautiful echo. "No one cares for me!" Sharp, hollow burst of a fart—then, in an instant, the door swings open, and the angel's voice vanishes into hum and clang, steel and clock hands, while the silence behind him glows.

He Glides without Offense

His mother had wondered
what blanket of dream
would shield him from the world's frost,
what bell echo in his voice
when he sang
to keep himself whole.

He glides without offense,
soldier in a silent army,
his lame arm hanging at his side,
a rope wrapped around
the wrist of his good arm
dragging a rattling steel cart
over sidewalk bumps, uphill.

Berkeley, early March.
A frantic hammering
Fractures the early morning air.
He looks around.
The pounding stops, then rages again.
Squinting upward, there, at the dry
pocked crest of a power pole,
he marks a small woodpecker hurling its beak
into dry wood, its body a blur.
"Damn," he thinks. "Don't he get
A headache?"

Crossing traffic,
approaching a narrow park,
he passes under dripping catkins
at the tips of live oak branches.
At the fountain

he bivouacs for an hour,
carefully rinses a shirt
in the faucet flow at its base.

His mother would
smile, perhaps, to see his provisions
carefully wrapped in a blue tarp.
He was a neat, quiet child
Whose eyes showed
Pain quickly, but resilience.
His gaze gave her strength
as she faded.
She knew he would
find his way
before she passed
when he was still a boy.
She did not know
he'd become a soldier
in a homeless army
far from home,
though she remembered the men
climbing down from freight cars
in Indiana
when she was a girl,
bedrolls slung across their backs,
chasing a rumor of jobs
in the scrap yards of the mills.
She read their eyes when she
could. Some hard and blank,
some calm with a faint but unmistakable
gleam, as if a secret blessing—
the candle of a remembered face—
lit their hard road.

Sana in Oakland

The sign above the entrance
reads *Sana Market and Liquors*
and pictures apartments of deep red brick
built against the desert horizon.

I stand across Telegraph Avenue
and imagine a shopkeeper inside,
the cellphone in his pocket
a long-distance filament
of wounded nerves,
direct line to Yemen,
where bombardment hollows the walls of night.

The fog is breaking in Oakland,
as blue fingers of noon sky
appear with sunlight.

Down the street
a cluster of stores
from the Horn of Africa:
Red Sea, Oasis, Zahara.
One day I watched a man park his
truck outside *The River Nile Market* and unload
sheep carcasses, bloodless and skinned
in a pile at his feet; then carry them,
one on each shoulder, through the kitchen door—
a harvest of sterile carnage,
unlike the mess of Sana,
where the princes' pilots scour
the city for targets,
cardamon and henna are scorched

into market stalls
beside other, more terrible stains.

Perhaps the man behind the market counter
has put his cellphone to sleep and does not
want to think about the pain in Sana.
There is plenty of pain, after all, in Oakland—
for which he sells small remedies
of hope and distraction:
Big Winner lotto tabs, salt peanuts,
mini-vodka bottles.

I too shut out the city's pain,
but it appears
when I don't expect it,
curled asleep in doorways at dawn.

Or maybe the man behind the counter
is talking to his brother
who stands behind another counter
eight thousand miles away, in Sana,
exchanging blessings
as his brother breaks the Ramadan fast.

Operation Crass Led

The Image Defense Force
responds to slander, January 2009

The people of Gaza
stand accused of asking for First World florist shops
when they don't even have enough water
to drink.

How do they expect to keep
their roses from wilting?

Imagine!

They want cloth for wedding dresses
when they're a tribe of thorns and tobacco stains.

They want luxuries
like foreign travel
to cancer wards
in Tel Aviv,
and to study on scholarship in London.

(When's the last time
you studied in London ?)

They want spare parts for incubators
and dialysis machines.
What's so special about *their* babies
or *their* kidneys?

The People of Gaza want libraries
when they have nothing to read
but the clouds of questions in their children's eyes.

They smuggle bandages and tampons
under the desert
when rags did the trick for centuries.

What's so special about the people of Gaza?
Why does everyone feel sorry for them?

We weren't shooting
fish in a barrel
at an Arkansas carnival.

We were defending
the Most Moral Army in the World
from the people of Gaza,
using maximum restraint,
fighting with one hand tied behind our backs,

hell, fighting
in a damn straightjacket
with the whole world looking over our shoulder!

This wasn't Genghis Kahn
burning old Baghdad to the ground
eight-hundred and fifty years ago

(George Bush wasn't the first, you know),

or Nazi airplanes
trying out their hellfire
on some helpless Spanish
village in 1937,

but you'd think,
if you listened to the people of Gaza,
it was cold-blooded murder.

Rules of Conduct at Adult Movies

For Peewee Herman

Do not lick your lips
No matter what crumbs
Remain there; saliva
Is a lascivious substance

Keep your hands to yourself,
Out of your pockets,
If possible firmly gripping
The stiff wooden arm rests
On either side of your seat

At moments of orgasm on screen,
You may release tension
By chewing,
Provided the popcorn container
Is held straight
In front of you.
If morsels fall to your lap,
Never attempt to retrieve them,
As your fingers
Will be easily tempted
There

The appropriate facial expression
Is somber, reflective,
With the exceptions of moments
When the armed forces appear in uniform,
Be they only inebriated sailors
Fallen upon one by one
By a single insatiable

"Navy Nurse."
At these moments
A brief, muted cheer is encouraged

It is suggested you bring
A textbook, pad and highlighter pen
With which to take notes
On cinematic technique
During intermission

Immediately report
Any snoring, hyperventilation,
Unnatural wriggling of bodies
Of the patrons surrounding
To the management

Beware of overtures
From other individuals
In the darkness

The odds are even
It's a cop

The Trial of Abraham

"And *it came to pass that God did tempt Abraham,*
and he said, Take now thy son, thine only
son Isaac.... and offer him there for a burnt offering...."
(Gen. 22:1-2)

Along the ridge of the arid canyon
Abraham approached, his wrists bound.
The stout guard followed, cloaked in gray.

The old man's gaze was hard and pure.
He sauntered at the very edge
of a red rock chasm.

"You've been brought before me," I said,
"to answer for your crime.
In this country no man can bind
his child for sacrifice."

"A *voice from heaven*
told me to do this thing."

"Many say the same, Abraham."

"*At the last moment,*
an angel called,
'Spare thy son.'

Then, I beheld a ram
behind me,
its horns caught in the chaparral branches.
I offered its bristling neck
to the pyre."

"Unlucky for that beast
who belonged to the land,"
I observed.

"What say you, Isaac?" I asked
the trembling boy,
his throat scorched
with a blue-black bruise.

*"Father would not meet my eyes
as he raised his knife above me.
I was too afraid to cry."*

"I must confine you, old man,"
I pronounced,
"deep in this arid canyon."

Abraham met my eyes,
*"So be it.
But I shall never disobey
Holy Instruction."*

As he was led away
his child ran after him, weeping,
then stopped, turned.

"You have made me an orphan!"
he wailed at me.

The guard, raising a hard hand,
blocked the boy
as he tried to follow his father
down the steep curling trail
of iron rock.

Pilgrim of Frost

Frost comes rarely
to these coastal hills,
like a passing saint
whose crystalline body
appears at midnight
in the moon's silence
beneath the feather-light step of the mole,
to vanish
in the warmth of noon.

In a hard morning wind,
I've come to worship its beauty.

The path winds above
crazy quilt branches
of live oak
stitched with lichen,
their trunks moss green
at the roots.

Gray winter vines,
blanched sword fern,
red purple tangle of
dogwood canes.

Here, at the coldest stretch
of shade-locked trail,
long stalks of dry grass
are thin white bones in dark earth.

Berry leaves, heart-shaped,
lie encased beneath a thin glaze;

frozen moss bleached yellow
at the verge.

The quiet bell of the wind
strikes coyote brush at my shoulder,
and a blossom escapes, pale starred puff
aloft in canyon air.

Aria

In the glare of afternoon heat
beside the cathedral's gold, bulbous domes
a frail figure—white hair, narrow face—
appears from the shadows.
Like a mechanical doll, she thrusts her arm forward,
hand opening in the beggar's ancient gesture,
while for an instant I meet the fierce
stoic light of her gaze.
Unexpected, her voice rises
pure and operatic, in melodic waves,
dilates and shimmers
above packed yellow streetcars,
stray dogs asleep under shade trees,
Odessa's somber imperial facades.
Then she waits, silent,
for a Ukrainian coin
in exchange for the golden
thread of her song.

Children Share the Hollow Arms of Stone

Children share the hollow arms of stone
with their companions:
the echo, the cockroach, the moth,
the floating moan.
They fill catwalks and courtyards
where their years are sold
to the makers of uniforms, badges,
alarms.

Children withdraw consent
from life inside the penitentiary,
mimicking screws and posting sentries.
If one is caught the others
rearrange their play.
They have for companions
the sound of clicking vaults,
the great bible of their faults,
the scrape and glide of trays.

The jailer's key is shaped like a cross.
When it turns, it stops the talk of the children,
who have for companions the bat,
the broom and disinfectant fumes.

Some want to fight
because they always win.
Others must find some sharp thing,
sharp enough to save their skin.

Children in the penitentiary
create a language
in the rhythm of their walk—

as if they were
born to dignity.
Their daydreams and forgettings
fill the crevices of hollow stone.

Their companions are the shovel, the grudge,
an oblique hunger for love.
Every week at the wall phone
a connection to Grandmother's scratchy tone.

What have you been eating?
Can you glimpse the sky?
Have you left your mark
upon the wall?
Make sure, boy, to stay alive.

For Wild Boar Stew

Kochi, Japan

At the base of a steep trail
of pine roots and red clay,
the village is quiet.

In a hollow shed,
rusted hoes and rakes,
a rice-planting tractor, a
cluster of cages—
empty, except for one.
Wild boars stir there,
mother and child.

Small-eyed, long snouts,
dusty gray-brown pelts.
They are mute, gazes bewildered,
moving in small, nervous circles.

Were they rooting at the edge of a garlic field
when the net came down
to tangle their steps?

Sniffing wet mountain loam?

The mother pushes her nose,
like an antenna
through the cage's wire grid,
sniffing for signals
from the passing wind.

As the child takes a step,
its delicate split toe
is revealed in a beam of sunlight.

A swallow dips into the doorway
and is gone.

Chapel of Green

This wild forest, chapel of green instinct, cradle and
graveyard of seeds,
rises beneath the highway. The city's nomads have cut
through the chain link fence at its edge, to reach their
campsites.

Bleached stalks of last year's fennel
and small, blackened thistle stars
poke through the fence's diamond hollows.
Wasps, moths and crows glide above,
to alight on tough acacia
quilted in pale yellow blossoms.

At the forest's heart a massive
concrete pillar rises to the roadway slab,
encircled by a snake of ivy.
Narrow sluices of blue flow above,
on either side of the thundering hum of wheels.

In early March blond tufts of pampas grass
spread like the tips of a man-high fans
beside supple, pink-flowering eucalyptus.
Broom blossoms spill over the edge
of the gray stone embankment.

The nomad camp is discreet.
Standing in oat grass in fog, draped in blankets,
they pass cigarettes and coffee at dawn.
They are vigilant, but not surprised
if a man in khaki uniform appears
with a clean-up crew

to declare their shelter
within this random forest
a crime.

River Love

Mukogawa River, Japan

When I came undone by fear
that the world would break in the wind,
love answered me with river grass.
Thin crests of dandelion,
water's light, quick as spiders
across the gun metal flow.

I wanted to know how to live in the world.
I'd asked the question many times
of the sparrow hawk and the cucumber vine,
of the river stones and the windows of morning.

The answer was always love.
It rose against my desperation.
It blossomed beside my habitual whine.
It laughed me down to my knees.

I asked at sandbars
where herons stood
above meandering water,
as the cold page of snow

sealed the brow of the river island.

Love's answer was always whole.
Before I could hold it,

I thought, it will be gone—

who can handle love for long?
But it returned in the rhythm of breath,

the zero root
of the body's song.

I'd asked the question of winter gulls
who ripple down into the river,
and I asked at the arc of midnight.

The question was simple; it dwelled in the bone;
it was cut from the flux and pulse of dreams.
It rose with a knowledge of cruelty
within the human home.

I asked who lives outside the fence, unable to enter,
who lives within it, unable to leave, who marks
the boundary with a chalk of threats, and who
collects fear for rent.

Love answered,
"Dismember every oath—
they snuff the lamps of intuition.
Give allegiance to the common word;
even its silence
holds truth's wild bird."

POEMS BY RALPH DRANOW

A Sly Sense of Mirth

Poet, artist, dear friend,
I miss your passionate intelligence.
Your life's pain-wracked end
Doesn't make any sense.

But the beauty you created
With fertile mind and heart
Won't ever be outdated
As long as people value fine art.

You fought for the outcast, the poor,
The lowly of the earth,
Made friends at every open door,
Had a sly sense of mirth,

Bore your long illness gracefully,
Gaunt, ravaged body finally set free.

At Work on the Garments of Refuge

(From a painting by Daniel Marlin)

Two brown-skinned angels
With brilliant red wings
And a sewing machine
Work through the blue night
To clothe the weary bodies of refugees.
Every garment is a sacrament,
Created with fierce love,
To honor and protect
The flesh and spirit
Of those courageous beings
Who, like all of us,
Deserve a life
Free of poverty, war, and oppression.

Angel's Promenade

(From a painting by Daniel Marlin)

The angel has descended to earth
To satisfy his curiosity
About what it's like to be human.
He's invisible,
Except to the artist's keen eye.
The angel strolls along city streets,
With his sturdy walking stick,
Like a sightseer on vacation.
He's dressed fashionably
For this special occasion:
Turquoise pants,
Dark blue sweater,
A large pink wing
Sprouting from his shoulder
Like a winding river.
I see so much suffering,
He thinks,
Determined to bring light to the darkness.
Tenement buildings sing arias in his presence.
The bus gleams with a fresh coat
Of green paint.
Underwear on the clothesline
Tangoes in the wind.

Grief

(From a dream)
(For Daniel Marlin)

My close friend Dan Marlin,
Brilliant poet and artist,
Is moving away.
Like a statue,
He sits erect in the back seat
Of a black Buick,
A bored-looking man,
Heavyset and middle-aged,
Behind the wheel.
Dan stares straight ahead,
Pale face scrubbed clean
Of any expression.
"Where are you going?
Come back!"
I cry out,
As the car starts up
And Dan's slender form
Fades from my gaze.
His absence is a quiet ache.
Wherever you're going, Dan,
May you find a good home.

Birds of the Hulo Night

(From a painting by Daniel Marlin)

A sickle moon smiles down
On a technicolor Hawaiian night.
Birds in bright red jackets,
Yellow silk shirts
Frolic in a thick tangle
Of green foliage,
Jaunty voices banishing the darkness,
Rounds sung in perfect harmony,
Celebrating the mystery and wonder
Of being alive.
This is no time to be sleeping.

The Poet as a Young Man

(In memory of Daniel Marlin)

"The function of the artist is to express love."
—KENNETH PATCHEN

Hungry for experience,
You and your U.C. Berkeley friend Louise
Hitchhiked to Palo Alto
To drop in on Kenneth Patchen,
The Ohio steel mill town poet
Who crystallized your outrage
About the Vietnam War.
His open-faced wife, Miriam,
Welcomed you in.
Walking stiffly,
Disabled from an old back injury,
Patchen lit a Chesterfield,
Emitting a smooth stream of blue smoke.
In his early 50s,
He looked older,
With his furrowed face,
Sad eyes,
Which sometimes flashed a mischievous gleam.
The four of you spoke for hours
About the world's cruelty and beauty.
"The big boys always start wars
For power and greed
And the little people serve as cannon fodder,"
Patchen said, sighing.
You quoted from one of your
Favorite love poems of his:
"As we are so wonderfully done with each other

We can walk into our separate sleep
On floors of music where the milkwhite cloak of
 childhood lies...."[1]
Young blood surging through your veins,
You wanted this magic time with Kenneth Patchen
To go on forever.

In the late afternoon,
He asked in his cracked
But deep, resonant voice,
With his quirky sense of humor,
"What do you want to be,
A butcher, a baker, or a candlestick maker?"
You replied, "Oh, I want to be a writer!
I brought some of my writing.
Would you like to read it?"
You tried so hard to write like him,
Be like him,
Shed your skin of privilege,
Certain he'd adore your rich imagery.
His craggy face crinkled in a smile.
'I think I'll take a raincheck."
You nodded,
Realizing years later
Your youthful, overblown attempts at profundity
Were better left unread.
Frightened by hearing stories of hitchhikers killed
 by truck drivers,

[1] "As We Are So Wonderfully Done with Each Other," from Kenneth Patchen, *Selected Poems* (New Directions, 1957).

The Patchens insisted on paying for your bus fare home.
You and Louise savored the ride back in comfort.
All your life, Dan,
Courage ran like a river through your wiry body.
Fear never held you back
From what truly mattered.
Decades later, Patchen's love poems
Still made your heart sing,
As your poems have done for so many of us.

Why?

Inhaling a jolt of
Cleaning fluid and sweat,
I asked my communist mother,
Why do Negroes smell bad?
The cleaning woman was on her knees
Scrubbing dirt from the bathroom floor.
I was six
And blacks were an exotic species to me
In the East Bronx of the 1940s.
I recall the cleaning woman,
Her whirlwind of words
And scalding eyes.
God must have been testing her,
A member of Father Divine's Mission.
Trembling,
I wanted to flee her fury,
To unsay my words,
Those five small words.
My mother, who looked as if
The world had descended on her shoulders,
Pleaded, He's only six.
But the cleaning woman,
Sparks leaping from her eyes,
Insisted I needed to be punished.
My mother managed to douse the flames
By promising to punish me
And giving the cleaning woman combat pay.
I don't recall being punished,
Just briefly scolded.
But I was like a sick animal,
Wanting to hide somewhere,
Deep in the forest or the earth.

Martha

(A friend's lunchtime story)

Racial prejudice is the sea
We all swim in.
It seeps into our skin,
Courses through our bloodstream
And invades our hearts.
When I was four years old,
I asked my mother,
"How come Martha's arms are so dark?"
She was my nanny.
She'd been washing dishes
And had soap suds
Up to her elbows,
So I noticed the contrast
With her upper arms.
Martha got upset,
And I was in tears,
Because I absolutely adored her.
She used to sit down and play with me
And listen seriously to my childish concerns.
How many adults do that with a four-year-old?
My parents were nice to her,
But my grandparents treated her
Like a speck of dust.
You know, I think white people
Envy black people's spirituality.
We can't stand to
Look at ourselves in the mirror.

A Voter Registration Conversation—2016

You bet I'm registered to vote.
My father was the head
Of the local NAACP in Texas.
He used to carry a gun on his hip
When he went to vote,
So nobody would mess with him.
A lot of these young kids today
Don't think voting matters.
My grandkids, for instance,
All they want to do
Is be on social media
And have a good time.
The schools don't teach them shit.
Pardon my French.
And they don't want to listen
To an old fogey like me.
But hey, my father carried a pistol on his hip
When he went to vote,
So, my friend, you won't ever catch me
Staying home on Election Day.

The New Neighborhood

I'm eleven
And we've just moved
From our Jewish cocoon in the East Bronx
To Flushing with its checkerboard of
Modest brick and stucco houses,
Neat lawns,
American flags.
It's a windy fall day,
Leaves playing tag on the ground.
Outside my house
A stocky kid with a blond crewcut
Greets me with unsmiling eyes.
We exchange names.
His is Allen Cage.
Then he asks if I'm Jewish.
Words are locked in the basement
Of my throat.
His pale eyes bite into my face.
"Why do you want to know?"
I finally say.
He shrugs.
"No special reason."
"Do you dislike Jews?" I ask.
He shakes his head
But peers at me
As if I'm some strange animal.
Cold sweat tiptoes down my back.
"Suppose I don't want to tell you,"
I blurt,
Then realize I've played the wrong card.
A smile leaks into Allen's eyes.

"I bet you're Jewish."
There's quiet glee in his voice.
My heart rides the roller coaster.
I murmur,
"Yeah, I'm Jewish. What are you?"
"Protestant."
His chest seems to puff out.
We're armored in silence,
Two alien species confronting each other.
My knees don't belong to me.
My throat feels like sandpaper.
"Do you wanna fight?" Allen asks
In a voice limping with politeness.
"No," I reply,
Surprised by his lack of enthusiasm
For religious warfare.
He face softens into near-friendliness.
"OK, see you around."
He struts away, arms swinging.
I should feel relieved,
But there's a melancholy song playing inside me,
A song with cryptic lyrics
And a melody I've heard somewhere before.

Every Writer's Dream

As people exit the plane
In San Francisco at night,
A large boy with a
Square, pale face and glasses
Turns to me with a nearly blank crossword puzzle.
"Excuse me, do you know this word?"
I ponder 1 across in vain.
"No, but 34 down is elisions," I say.
"Are you an English professor?" he asks.
I smile. "No, I'm a writer."
He stares. "Really? What do you write?"
"Mainly poetry."
"We read poetry in my eighth grade class,"
He declares,
Then extends a plump hand.
"Hi, my name is Tom."
We shake hands.
"Am I boring you?" he asks.
"No," I tell him.
He shows me his Ray Bradbury book.
We briefly discuss it,
Then he wonders again if I'm bored.
"Can I see one of your poems?" he asks.
"I'll give you my book, Tom."
He shakes his head.
"I'm not a cheapskate.
How much is it?"
He pays me,
Then with elated eyes
Gazes at the front cover.
"I think I'll like this," he exclaims

And starts reading,
Reciting a few lines,
Like a gourmet savoring a good meal.
A blonde, sharp-featured stewardess comes over.
"This guy's a writer," Tom announces.
She murmurs politely,
Squeezes out a smile,
Then hands him an envelope.
"I'm sorry; we're not allowed to take tips,
But thank you."
His eyes dim. "Why not?"
"It's against the rules."
"But why?" His voice breaks.
The aisle is empty now
And three other stewardesses surround Tom,
Gently repeat the party line.
He looks lonely,
As if he's wandered onto the wrong planet.
But in the terminal,
At the sight of his smiling parents,
He's his old self.
"Hey, Dad, this guy's a writer!
I bought his book," he shouts.
His father flicks tired eyes at me,
Mumbles a greeting.
"Goodbye, Tom," I say,
Taking leave of my ardent admirer
To re-enter the ordinary world.

Autumn Gifts

(From a photograph by Laura Sutta)

Her beauty eludes
Hasty eyes.
She stands in a corner,
Unseen,
No dance partner.
"I can dance
Just like spring and summer,"
November insists
She dons grass slippers
At the outdoor ballroom
Of Lake Merritt,
Twirls round and round
With the geese,
To their hoarse, honking sounds.
She's wearing a grass dress
Stitched with glistening red leaves
For buttons,
Pale hair festooned also
With bits of scarlet.
When she's deliciously dizzy
From dancing,
She dips her hands into
The cool serenity of the lake,
Splashing her flushed face,
As her reflection
Ripples in the water.

Super Cool

The young black man
At the farmers' market,
Baseball cap turned backwards,
T-shirt proclaiming: Super Drummer,
Wields drumsticks with piston-like hands,
Stinging cymbals and drums,
A rhythmic storm
Over the recorded soul music,
Making my blood tango.
A wide-eyed crowd has gathered,
But he seems unmoved by it,
Although occasionally he tosses
A stick in the air,
Deftly catches it,
Then nonchalantly resumes
His musical assault,
Head swiveled sideways,
A small smile
Whispering in his eyes.
When a stick inadvertently
Flies from his hands,
Women quickly retrieve it for him,
Which he receives impassively.
A rain of bills
Pours into his black instrument case,
But he pays no attention.

The Dance

(From a dream)

A lonely spectator
Hugging the sidelines,
I observe smiling couples
Gliding about on the dance floor.
Then I notice a man in his 40s,
Face flecked with pimples,
Dancing by himself
With quiet ease.
Suddenly he approaches me,
Eyes glistening, arms outstretched.
"Would you like to dance?"
His voice soft, relaxed.
I hesitate.
Will I be seen as gay?
His pimply features remind me
Of the virulent acne
Blighting my youth.
But his self-possession
Is disarming.
I move tentatively toward him,
Glance uncertainly about,
But soon begin moving in synch with him,
Shedding my self-consciousness,
That old ache
Of separation from myself.

An Unheralded Artist

The chubby Asian woman
Snips at my hair,
Like a painter's delicate brushstrokes.
When I sniffle,
She advises me to keep my windows open,
Then scurries to a counter,
Brings back her Chinese newspaper.
"I read about him in the paper.
His paintings sell for lot of money.
He paint everything upside down,
Like a child."
She laughs shrilly,
Inquiring, "What's his name?"
I figure out she means Picasso.
She asks me to write his name down,
Pronouncing it slowly,
As if sampling some strange new food.
Gesturing, scissors in hand, she repeats,
"He paint everything upside down,
Like a child.
But his paintings sell for many million dollar.
Why is that?"
I shrug. "That's a good question."
She shakes her head,
Then continues sculpting my hair
Until it flirts with perfection,
An unheralded artist
Who charges me a modest amount
And wishes me a nice day
In her hurried, hard-earned English.

What Would the Dalai Lama Do?

"Do you want to go ahead of us?
I say to the heavyset, middle-aged woman
Behind my wife, Naomi, and me on line,
Holding bread and a gallon of milk.
As she puts her items down,
An older woman behind us,
Hollow cheeks, wrinkles, glasses,
And an overflowing grocery cart,
Calls in a gravelly voice,
"Take my things too, Darlene."
Darlene hesitates.
The woman shakes her fist.
"Come on! You can't leave me standing here!"
"OK, Ma."
Ignoring us, as if there's a veil between us,
Darlene begins transferring her mother's groceries
To the checkout counter.
Naomi and I exchange incredulous glances
As Darlene piles frozen foods, cookies, bottled water
Onto the counter.
My disbelief soon shades into anger.
I contemplate a verbal knockout punch,
Dropping Darlene to her knees,
Forcing an apology,
When Naomi, looking amused, interjects,
"What would the Dalai Lama do?
Probably smile and bow
And fold his hands in blessing."
Her insight startles me,
Clears the fog from my mind,
Sober hands pulling me from the precipice.
"Thank you," I murmur.

The Year I Discovered John Steinbeck

Fifteen and dug deep in the trenches of adolescence,
Pimples blooming on my cheeks and forehead,
Like poisonous flowers,
I was undoubtedly the ugliest person
In the whole world.
After I read my book report
Out loud in class,
Blonde, attractive Helen made
An unexpected overture toward me,
And I fled,
Knowing I would disappoint her.

Then, Bernie Kaplan, intoxicated with
His shiny new three-gear bike,
Urged me to ride it.
Ashamed to admit my ignorance
Of technologically advanced bikes
And determined not to seem like a wimp,
I said OK.
Trying to brake going downhill,
I crashed to the pavement,
Breaking my collarbone.

Heavily bandaged and housebound,
Held hostage by a humid New York summer,
I was hot and miserable
Until my mother put salve on my wounds.
"Would you like to read some books by John Steinbeck?"
She asked.
Reading Cannery Row, I lost and found myself
In the whirlpool of other lives:

Mack and his gang of ne'er-do-wells,
Doc, the eccentric marine biologist,
And Frankie, the lonely boy who loves him.
Steinbeck's warm embrace of outsiders,
Imperfect people like me,
Eased my burdened heart.
Melancholy ebbed away,
Replaced by a subtle stream of ecstasy.
Someday, I thought,
I'd like to write like John Steinbeck
And make other people glad to be alive.

Paramedic

You see some pretty rough stuff as a paramedic.
Babies with broken bones,
People with gunshot wounds.
We have the second highest suicide rate,
Right behind dentists.
I was hanging out with another paramedic,
And he seemed OK,
But then the next day
He's gone, suicide.
You have to be able to step away,
Take a mental vacation from the job.
Why do I keep doing it?
Well, it keeps me on my toes.
Twenty-three years ago I was bored stiff
Selling lawn mowers at Sears.
Becoming a policeman sounded good,
And then the Rodney King incident happened.
I thought about becoming a fireman,
But I didn't want to burn to death
Climbing up a ladder.
So I took an "easy" job.
Actually, only 7% of our calls
Are life and death.
You get a guy who eats too many pot brownies
And thinks he's dying,
Or a hypochondriac who has some new
"Life-threatening" illness every week.
But I'll tell you, delivering babies,
Bringing new life into the world
While it's still pure and innocent,
That's the ultimate high.

Linda

In the supermarket,
I notice a slender, sixtyish woman
With a pale complexion,
Small, upturned nose
And think: that looks like Linda.
We lived on the same block,
Dated two decades ago,
Read short stories and poetry out loud,
Shared our writing,
Flirted outrageously.
Lonely after a divorce,
I longed after Linda,
Ignoring all the stop signs:
Barbed words wrapped in velvet,
Stiff body language,
Until we crashed,
Our banged-up egos
Staggering from the wreck,
Fleeing in separate directions.
Still, I was haunted by
Her remote beauty,
Her oceanic eyes.

Married now, less lonely,
I get in line with my groceries,
Startled to see the same woman
Move into line behind me.
Is it really her?
I'm tempted to speak,
But don't,
Recalling her averted face,

Her stony silences
Whenever we met on the street
For several years afterwards.
I close my eyes,
Breathe deeply,
Hope the line moves quickly.
Then other memories surface:
Losing her mother at 12,
Never knowing her father,
And my best poem
Forged in the crucible
Of our brief time together,
A poem of yearning
For something more substantial,
More eternal,
And silently I bless our troubled souls.

Next-door Neighbor

Burly, hunched, a gnarled bear,
Peter is watering his manicured garden
Of cactus, lemon tree, lavender bush.
His wrinkled face lights up
When he sees me.
"How are the liberals doing?"
"I've been called worse," I retort,
Glad he's not calling me a communist.
"Did you hear about the impeachment?
What do you think of our socialist president?'
He demands,
Cupping his hand to his ear as I reply,
"Clinton's a sex maniac, not a socialist."
Peter frowns.
"He never saw a government program he didn't like.
That's my definition of a socialist.
Besides, he was a draft dodger."
Peter served four years in the South Pacific.
"Well, I'm waiting for your expert opinion,"
He insists,
With a sideways scowl.
"I'd like to hear about your experiences in the South Pacific,"
I say, to divert his attention.
He holds up his hand.
"Wait a minute.
We haven't resolved this issue."
I laugh. "We're not going to agree,
So let's talk about something else,
Like your World War II experience."
He sighs. "I had a few close calls.
I'm lucky to be here.

I contracted a bad skin disease
That took me years to get rid of."
"It sounds awful," I reply.
He shrugs. "We did what we had to do."
I think about his wife.
I haven't seen her in a long time
And wonder if she died or left him.
"How are your grandchildren?" I ask.
A smile steals over his face.
"I'll be seeing them tomorrow.
They're the best thing in my life."
This feels more real than all the arguing.
I begin to relax,
But then he declares,
"I still say Clinton's a socialist."
"Maybe," I reply,
As if conceding a toy
To a more aggressive kid.

Beyond Us and Them

Dr. Kaplan dons magnifying goggles and gloves,
Hovers over me
Like a large animal,
As his keen gray eyes
Scrutinize my body
For hints of skin cancer.
He murmurs the names
Of various conditions
He encounters on his journey,
As if cramming for a test.
No cancer, he tells me,
Then checks for dandruff, athlete's foot.
Meanwhile, we chat.
He's been reading the autobiography
Of Israel's ambassador to the United States.
"Obama's an enemy of Israel and the Jewish people,
So he's my enemy,"
The doctor declares.
"But the U.S. still gives Israel a lot of military aid,"
I gingerly observe.
Dr. Kaplan's thin lips tighten.
"When Israel was defending itself against Hamas in Gaza,
Obama objected to helping Israel."
"Hm," I offer noncommittally.
Kaplan's eyes are twin flames
Behind his goggles and glasses.
"Obamacare is socialized medicine.
It penalizes practitioners like me.
Obama is a Russian communist."
I stifle an urge to laugh,
A risky indulgence with one's doctor.

Cautious, centrist Obama a flaming Bolshevik!
I steer the conversation to a safer subject,
Ask if he thinks about retiring.
"No!" he says emphatically.
"I love my work.
My father was a dentist
And wanted me to become one too.
But ever since I was a kid,
My dream was to become a doctor."
"That's great," I reply,
Feeling my body relax,
Relieved we've escaped from
The prison of us and them.

Cocoon

Only a short distance
From the bustle and chatter,
The serious business of recreation
At the Hawaii Hilton Hotel,
Naomi and I lie in a hammock
On a balmy winter night
Glittering with stars
And a full moon.
As we gently sway,
Our bodies sing,
Surrender to night's embrace,
The wind licking our faces.
We revel in our island of silence,
Our silken cocoon,
And the untrammeled sky
Winking at us,
Trembling with light.

Going Outside

"Would you like to go outside today?"
I ask.
My wife's eyes glisten.
"Yes, I would."
She's had a recent hip replacement,
Been cooped up for over a month.
I hold the front door open
As she eases the walker out.
Then I place it by the front steps
And walk back up to meet her.
We lock arms,
Thumping down the steps
In synchronized fashion:
Right, left, right, left, right, left,
A senior marching band.
Then she reclaims her walker
And we inch down the block,
Like centipedes,
Banishing time and duty,
Drunk on the miracle of walking,
Of being alive with one another
On this particular Sunday afternoon,
Our faces glowing with winter cold.

Playing Catch

"How about playing catch?"
I invite Naomi
For a work break
On a silky fall afternoon.
Her flushed face sings
As we toss a tennis ball
On our tree-lined street.
She's enjoying the gift
Of movement,
Freedom from the shackles
Of her computer.
A sensitive, troubled girl,
She hated P.E. classes,
Shrill whistles,
Frantic competition,
Any kind of ball.
But now, her hands are magnets
Welcoming the green, fuzzy ball.
She takes in the easy flow
Of my movements.
"Hold your body sideways
And draw your arm back
When you throw,"
I counsel,
Demonstrating.
Gradually her body unfurls,
Like a young flower
Opening to the light.
"Thanks for being so patient,"
She says,
Sated with the rhythm

Of throwing and catching.
We stop.
Her pale eyes glimmer.
Her voice dances with gratitude.
"This was just what I needed."

A Humble Guy

*(Based on a conversation while watching a Golden State
Warriors playoff game in a pizza parlor)*

The Warriors remind me of the Harlem Globetrotters,
Fluid passing, smooth teamwork.
Another world from my family.
My father left when I was one,
Because my mother drank and took drugs.
She took me from Tennessee to Colorado
To be with the Hari Krishnas.
They separated the parents and children,
So the parents could give everything
To working on the farm
And recruiting new members.
The kids were put into this dark, dreary place,
No electricity or running water,
Like being in prison.
I didn't see my mom for five years.
She took me away when she found out
Children were being sexually abused
And the leaders were stealing.
I went to live with my grandmother for a while.
Wow! Did you see that?
Curry just hit a three from maybe 40 feet out!
Then I spent time in foster homes.
Some were caring, people with good hearts,
And in others you were a second-class citizen.
To escape, I married young, foolishly.
My wife, like my mom,
Was a prisoner of booze and drugs,
But we had two beautiful daughters,

And I got custody when we separated.
Being a male single parent raising two daughters
Is like stumbling about in the dark
Without a flashlight,
But my girlfriend the past four years
Has been the mother they never had.
My older daughter just got a scholarship
To a small New England college,
And the younger one, a junior in high school,
Makes some pretty nifty moves on the soccer field.
Hey, Thompson's settling into a rhythm now,
With that feathery jump shot of his!
He and Curry are the best backcourt in the NBA.
Somehow, I've juggled college, parenting, work,
Keeping all the balls in the air,
Mostly with construction jobs.
I'm a hands-on kind of guy,
Was on the wrestling team in college and have a
Cauliflower ear to show for it.

I'm going to nursing school now,
Because I've always liked helping people.
I love how the Warriors play so unselfishly.
Curry is a humble guy,
A good Christian and family man,
And Durant is a good guy too,
Heavily involved with charities.
Looking out for one another,
That's what it's all about.

A Chinatown Encounter

"Hello." A quiet voice
Slides into my ears
On a busy Sunday afternoon
In Oakland's Chinatown.
I turn around,
See an elderly black man
With sad eyes
And a brown head wrap
Covering the sides of his face,
Like an Arab.
It feels like a surrealistic movie.
Does he want money?
"Are you homeless?" he asks.
"No." A bit surprised.
Casually, as if asking for the time:
"What's your phone number?"
"Why do you want to know?"
I demand,
Then realize it's me he wants.
He's not menacing,
But I walk a little faster,
And his plea,
A lonely balloon,
Floats into the cool fall air:
"My telephone number is (510) 867-3905."
Moments later, he tosses his number again
At my retreating back.
At the bus stop,
My heart flutters like a wounded bird,
His hungry words clinging to me,
Like barnacles.

A Non-Literary Conversation

"What are you reading?"
A soft voice at the bus stop.
Prepared for literary talk,
I glance up into large, puppy-dog eyes.
When I show her my book,
She looks blank.
"Do you like to read?"
I ask.
'I can't see too well.
I got hit by a car.
It knocked out a tooth."
Smiling, she reveals it,
Like a child showing off
Her finger painting.
"I'm sorry," I say.
She shrugs.
A local ministry is trying to find housing
For her, she discloses.
'You know, before I came here,
I lived in a cabin way back
In the Santa Cruz mountains for 40 years."
A wistful expression flits over
Her angular face.
"I had electricity off the grid
And a wood burning stove.
It was far away from everything."
Leaning in closer and whispering;
"Maybe I shouldn't be telling you this,
But my friend built a bomb shelter there."
I stare at her.
"People are still building those?"

She nods. "Yeah, but the problem is
Everything is sinking in California,
So the shelter's just gonna disappear."
I'm trying to take all this in,
When my bus shows up.
"Goodbye," I tell her,
A small ache in my heart.

Mother and Child

Pale, slender,
She sits on the bus,
Holding her infant son in her lap
With sure hands.
It's a cold autumn night,
And his tiny features peek out
From his snug pajama suit.
She lifts him to his feet,
Gently bounces him up and down,
Their bodies rocking
In a slow, fluid dance.
At their stop,
She lowers him into an enclosed stroller
To keep him warm.
Observing all this,
I'm heartened by its
Simple manifestation of love
One week after the brutal election.

Jack

"When I had a paper route
In the projects in Detroit,
These two older kids
Wanted to steal my money,"
My 73-year-old neighbor Jack
Is telling me
In his metallic, high-pitched voice.
'Well, they jumped me one day,
Thought I was easy pickin's,
But I had a pretty good left jab
And I kept popping it in their faces,
Snapping their heads back.
They left me alone after that."
He laughs,
Revealing two missing front teeth.
Jack's usually the star of his stories,
Many about his basketball prowess
Leading his college, army, and amateur teams
To victory against superior odds.
"I always liked to guard
The opposing team's best player,
Shutting him down," he declares,
Pride glinting in his bespectacled eyes.
Was he really that good?
Slightly stooped but tall and vigorous-looking,
Jack looks as if he could still play staunch defense.

He produces countless commonplace photos,
Documenting flower gardens and parades,
He's always inviting me to look at.

I dutifully peruse them,
Feed him the compliments he craves.

One afternoon he informs me, a bit breathlessly,
"You know, I walked three miles to Broadway and 10th
Because Smart and Final had a sale
On honey wheat bread for $2.49 a loaf.
You can't beat that."
He's beaming,
As if he's just won the jackpot in Reno.

But whenever I'm tempted to dismiss him,
I recall his quiet offerings:
Trimming bushes by the side of the road,
Sweeping up debris,
Helping out neighbors.

One drizzly autumn evening,
He's busily at work near my house.
"What are you doing?" I ask.
He glances up, leaning on his rake.
"I'm raking up these leaves,
So people won't track wet leaves into their house."
Digesting this, I reply,
"You're our neighborhood angel."
He shrugs, then blurts,
As embarrassment flits across his face,
"Yeah, well, someone's gotta do it."

Sheila

"Now that damn shyster next door can't get in,"
My neighbor Sheila snaps,
Handing me the new laundry room keys.
Startled by her vehemence, I reply,
"I didn't mind her using it sometimes."
A fierce light glimmers in Sheila's brown eyes.
With her pug nose,
She looks like a fierce little bulldog.
"Well, I did.
She's been using our water and electricity,
And she overloads the washer.
That's why it's been breaking down."
Tentatively I venture,
"Are you sure it's her?"
Sheila nods, lips curled in a knot.
"I saw her coming out of there
With a humongous pile of laundry.
That's all I need to know."
"Have you tried talking to her?"
I suggest.
Sheila glares at me.
"Hell, if I did that,
Fists would start flying."
"Really? Well, maybe you did the right thing,"
I concede.

Before she quit drinking a few years ago
And got a part-time job at a bakery,
Sheila scared me.
She and her boyfriend, Andy, staged titanic brawls,
Replete with screams and thuds,

The whole house vibrating,
As if the end of the world were at hand.
She took a passionate dislike
To some of our neighbors
For seemingly trivial reasons,
American flags looming from her windowsills,
Like City Hall.

She's softened in the past few years,
Brings my wife and me homemade banana bread,
Bagels, lox, and cream cheese from the bakery,
Rakes leaves, plants tomatoes and flowers
By the side of our green shingle fourplex,
And lavishes affection on her new Chihuahua,
Who's replaced the daughter who left home.
Fights with Andy are rare.

Recalling all this, I say,
"Thanks for the keys
And for looking out for everyone here.
What would we do without you?"
Sheila's warrior face relents,
Breaks into a grin,
Her eyes vulnerable, strikingly beautiful.
She clutches my hand and exclaims,
'You're a good guy, Ralph.
Have a great day."

The Unnecessary Death of Scott Beigel

Pale and bleeding,
Young life ebbing away
On the floor outside your classroom,
You were struck down by a bullet
From a 19-year-old's semi-automatic rifle.

Nikolas Cruz learned to shoot a gun
At age 13 in Junior ROTC.
Despite numerous violent incidents,
His obvious mental illness went untreated.
One more blasted soul in America
Trying to exorcise his pain with a gun.

Geography teacher, cross country coach
At Marjory Stoneham Douglas High School
In Parkland, Florida,
You, Scott, ushered fleeing students
Into your classroom,
Elevating their safety above your own,
And paid the price,
Imminent marriage aborted.

You told your mother
If you were ever killed in a school shooting,
You didn't want to be in the spotlight,
Because the focus should be on solutions
More than the victims.

Still, hundreds of people gathered to remember you,
The dedicated teacher.
Hopefully, you won't be just another statistic,
Collateral damage in our frontier culture,

But that your death and the others at Parkland
Will be the alarm jolting us all awake.

Much Love

Slender, wearing a white summer dress,
She calls to her young son,
"Come back here, sweetheart."
He's slipped away from her
And the long post office line.
"Would you like to hear a story?"
She offers.
He nods. "Yes, a story."
She draws a book from the stroller,
With a pizza container resting on top.
Then, a few feet in front of me,
She sits and he reclines on his side,
His handsome brown face
Glued to his mother,
Who reads a children's story about cars
In flowing Spanish,
With sweeping gestures.
Occasionally she pauses
To stroke his thick, dark hair
Or respond to his questions.
The post office has become
Their own private living room.
Watching this intimate scene,
I almost forget where I am.

Later, at the postal window,
The clerk, a large woman
With heavy-lidded eyes,
Wearing a kerchief,
Smiles warmly,
Asks, "How are you today, brother?"

She too has transformed this drab room,
With its silent queue of patrons,
Plexiglas windows,
Stacks of mailing envelopes,
Into sacred space.
She sells me a book of stamps,
Hands me a receipt.
Her parting words: "Much love,"
Send me out the door
Bathed in light.

Lake Merritt Collage

Saxophone sounds,
Harsh and sweet,
Tremble in the air
As Canada geese congregate,
Their gait stately,
Like delegates to an international conference
To lower trade barriers.
Tress sport punk haircuts
Of green, orange, yellow,
While a tall, broad-shouldered guy strolls by,
Processed orange ponytail
Spilling to his ass.
A duck pecks,
Somersaults into gray-green depths,
Emerges with slimy black treasure
As a young girl runs,
Arms flapping like wings.
"Watch where you're running,"
Her mother warns.
A lone seagull perched atop a light fixture
Regally surveys his domain below.
Meanwhile, a young female jogger glides;
An older woman churns,
Arms and legs pumping
In a vat of molasses.
The distant rumble of drums.
An elderly Asian man scoots by
In a wheelchair,
An American flag fluttering in back,
Like an amulet
As a young lesbian couple hold hands,

Weave a private tapestry
Of words and smiles.
Sunlight crinkles the lake
Like champagne bubbles.

Kibbitzing as a Fine Art

Standing at the Lake Merritt bird sanctuary,
Idly watching the ducks,
I notice two sixtyish black men
On a bench nearby,
Drinking from bare gray cans
And calling out to passersby.
"What a cute little girl you got there!"
The one wearing a battered Stetson,
Long shorts, plaid shirt
Informs a woman wheeling a baby carriage.
"It's a boy," she retorts.
Stetson and his companion
Break into gravelly guffaws,
Lean bodies quivering.
"My bad, my bad, my bad,"
Stetson repents, shaking his head.
A mother walks by,
Holding her little girl's hand.
"She's gonna be a heartbreaker, I tell you,"
Stetson remarks,
And he and his silent sidekick
Indulge in another round of merriment.
Three teenage girls saunter past.
"How are you beautiful young ladies doing today?"
Stetson inquires.
"Fine, and you?" one girl replies.
"I'm blessed, baby.
You all have a blessed day."
And with his easy happiness,
Stetson has blessed my day.

Elvis (Concert in Hawaii, 1973)

I'm unexpectedly glued
To the TV screen
And the puffy-faced man
With the white, wedding cake jumpsuit
Hugging his plump torso.
He looks like a debauched angel,
Bedroom eyes, coal-black sideburns,
As he renders "Heartbreak Hotel"
And "Don't Be Cruel"
In a deep, aching voice.
Despite my advanced years,
His sound seeps inside me,
Creates a small pocket of yearning.
He smiles flirtatiously,
Does a little dancing,
But surprisingly his body is mostly quiet,
Except for arms flung wide
In scripted triumph
After each song.
Sweat pools on his pale forehead,
And young women appear on the stage
At frequent intervals,
Offering pristine handkerchiefs
He staunches the tiny flood with,
Then hands back,
Priceless souvenirs.
Acolytes crown him with leis
As he bends down
To consecrate their kips
With hasty kisses,
Gifts to remember
The rest of their lives.

Combing Lucinda

Lucinda sidles over to my chair.
Bright yellow eyes gazing up at me.
I make inviting sounds and gestures,
But she circles me warily,
Refusing instant intimacy.
Finally, I reach down,
Pluck her through the air,
Onto my lap.
She jumps off,
So I wait,
Allow her to initiate.
After a bit more pacing,
She bounds onto my thighs,
And my fingers exult,
Traveling the soft terrain of her body,
A swirl of black, brown, and white.
I glide the cat comb through her fur
With measured movements,
As if sewing
Or painting a picture.
She wags her tail,
Makes squeaky noises,
Sounding halfway between pleasure and complaint.
Having harvested a bumper crop of hair,
I lay down the comb.
Intently, she kneads my sweater,
Like a nursing kitten,
Then stretches out luxuriously,
Eyes slowly closing,
Ready for a well-earned nap.

Snapshots of Sophie

Part 1

As dawn breaks,
She leaps onto the bed,
Perches behind my head, purring,
Demanding breakfast.

At bedtime she's a warm pillow,
A plump gray presence nestled against my legs.
When I shift about,
She slides off.
Hours later, I discover her
Reclining inches from my nose.

Patient, self-effacing,
She keeps me company
While I'm working or reading.
Later, though, she butts and paws me,
As if to say:
Time for a break—for me.

When I come home,
Turn my key in the lock,
She's a track star,
There in an instant,
As if I've never been gone.

Every morning she yowls,
And I put a dab of yogurt
On my finger.
She laps it up,
Her ecstatic tongue whispering against my skin.

Part 2

One day I notice
Food left on her dish,
An unusual occurrence.
When this continues
And saliva starts trickling down her chin,
We take her to the vet,
Discover she has a cancerous swelling
Underneath her tongue.
We try to save her with special cat food
And medical marijuana,
But each day eating becomes more labored,
Her bones more prominent,
Her life force a little feebler,
An odor of decay about her.
We pray for a miracle,
But the fateful day soon arrives,
Our last shred of hope
Crumpled in the gutter,
As Sophie's gaunt body,
Wrapped in a towel in Naomi's lap,
Breathes its last breath.

Innocence

At the BART station
I notice a tall young guy,
Wearing black-framed glasses,
Water bottle in his left hand,
Clutched in his right,
A mellow Chihuahua,
Alive eyes,
Like shiny black beads.
The guy stands before the turnstile
For a long moment,
Twisting to the left,
As if reaching into his pocket
For his ticket.
But then two high, supple steps
Carry him over the stile,
Coolly headed for the stairs.
Startled, I stare at
The back of his sweatshirt
And the dog's innocent eyes,
Twin pinpoints of light,
Receding in the shade
Of the BART tower.

Voyeurs of Misery

(In memory of my grandfather,
Abraham Rosenfeld, 1886-1980)

Reading your journal, Grandpa,
I picture you at 14,
Bony cheeks pitted with smallpox
And that flame lurking
In the backroads of your eyes,
The look of a child
Who is already an adult.
You were sleeping in a park in Odessa,
Surviving on dreams and stale bread.
Finally you got a job in a factory
Making iron beds for hospitals.
You joined the union,
Began reading revolutionary literature
Like a starving man ushered into a banquet.
"I was swallowing it in my rest time."
The world swam into focus.
You saw an end to:
Mean bosses, growling bellies, school cut short at 13.
"The boss was always on our neck.
 'What are you yawning there, you?'
He kept on hollering."
He watched the workers through a peephole.
You were working a drill machine,
Using both hands, peddling with your feet.
When your tired hands let go,
The drill broke.
"Every time the boss came running and screaming,
 calling us

All kinds of names for breaking the drills."
At the end of the week
Your pay was short 60 kopecks for four broken drills.
Unfair! Your belly howled.
The boss was deaf to your protests.
The flame in your pale eyes flickered
Into the dark underside of a smile.
You filled a rubber sprayer with ink,
And one afternoon ruined his private movie,
Bathing his eye in blackness.
"It was some fun to see him running from the office
Into the shop with his face and eye blackened."
He grabbed an iron bar to strike you,
But you were out of the shop,
Feet dancing like the wind,
Laughter exploding from your skinny body,
On your way to the next skirmish
With the voyeurs of misery.

The Gringa Feeds Stray Dogs
in San Cristobal de las Casas

Feeding all the homeless dogs
Used to be the highlight of my day,
But not any more.
The alphas are like thugs,
Chasing the other dogs away,
Wanting to hog all the food.
It feels like a battle,
Making sure they all get something to eat.
Sometimes the females are the worst.
One dog—I named her Mandy—
A cute little cocker spaniel,
Didn't show up for five days.
I thought she'd died.
Yesterday she was there again.
I was glad to see her,
But she was a pint-sized terror
Of fangs and shrillness,
Like she hadn't eaten for five days.
My illusions were shattered once again
On the stubborn rock of reality.
I just have to accept that homeless dogs
Might not have the greatest table manners.
But a few dogs are different,
So I have some hope for them.
I'll keep feeding the dogs,
Mainly because of them,
The gentle ones with big, sad eyes,
The ones I could get to love.

Glisten like the Stars

The years have crept up on me
On slippered feet.
How much more time left, God,
To transmute lead into gold?

On slippered feet,
Each second a laboratory
To transmute lead into gold,
An alarm clock urging: wake up!

Each second a laboratory,
Each breath a new adventure,
An alarm clock urging: wake up!
Glisten like the stars you're made of.

Each breath a new adventure,
The gift of grace.
Glisten like the stars you're made of.
Light up the night.

Me Too

In my 20s,
I hungered after women
But feared the messiness of commitment.
Lust corrupted my heart.

I hungered after women.
Have you ever forgiven me, Jane and Penny?
Lust corrupted my heart,
Blinding me to the balm of your love.

Have you ever forgiven me, Jane and Penny
For my youthful male selfishness,
Blinding me to the balm of your love,
The warm shelter of your arms?

For my youthful male selfishness
I apologize too many years later.
The warm shelter of your arms
That I so carelessly tossed away.

Some Ground Rules for the Pandemic

Love makes hate laugh,
Says, "Don't take yourself so seriously."
Love kisses fear on the lips,
Says, "I'll take care of you."

Don't take yourself so seriously.
We all bleed the same vermillion.
I'll take care of you
Because you are me.

We all bleed the same vermillion.
Love gives away her lunch,
Because you are me
And I am you.

Love gives away her lunch,
Enjoys watching you sate your hunger,
And I am you
And you are the moon and the stars.

Shopping during the Pandemic

My body tightens, like a drum.
"Don't you know we're supposed to stay
Six feet apart?"
I fume,
Stifling an impulse to berate
The lanky young guy
Steering his grocery cart
Precariously close to mine.
I weave in and out
Of the paths of often preoccupied shoppers,
Like a running back eluding tacklers.

At the check-out counter,
The Middle Eastern checker
Snaps at me, "Move back!"
Her brown brow furrowed,
Dark eyes a sorrowful song
Playing above her mask
And the plastic partition
Only partly protecting her.
Chagrined, I step back and realize
I've been oblivious too,
Endangering this woman who,
Unlike me, working from home,
Is compelled to toil
In the midst of the maelstrom
For infinite minutes every day.

Pitching to Hitler

(From a dream)

I'm pitching to Hitler,
A runt with scrawny arms and legs.
Fighting off an inside fastball,
He hits a dribbler
In front of the plate.
The catcher pounces on it,
But Hitler ruins like the wind,
Arms whirling.
He beats the throw to first,
Then hurtles into second
Before the startled first baseman
Can react.
Hitler is headed for third.
The first baseman fires the ball.
Hitler slides, spikes flashing,
Grazing the third baseman's shin,
Causing him to drop the ball.
On the next pitch,
Hitler races toward home,
Barreling into the catcher,
Who, unfazed, tags him hard in the face.
"Out!" the umpire shouts.
Face beet-red, eyes bulging,
Hitler screams and spits at the umpire,
Who throws him out of the game.
I let out my breath.
We barely managed to stop Hitler
From going all the way!

My Mother Speaks of Her Early Years

My heart beat like a drum,
Skinny body burning with shame and outrage,
Crowned with a dunce cap in the corner
Because I was late for school again.
School was a foreign country,
My parents' Yiddish devalued currency,
So I dawdled underneath the train tunnel
On the immigrant streets of East Harlem.
I wanted to begin my first boycott.
"Rachel, my child, we're poor," my mother said.
'Stay in school and you'll become somebody."
But I wasn't cured of my dawdling
Until years later I fell in love
With geography and the lure of faraway places
In Miss McNally's seventh grade class.
Tashkent was more fun than East Harlem,
Where the Irish and Italian boys
Beat up the girls,
Socking us on Halloween with flour-filled stockings.
I had a bad case of acne
And put on makeup to hide it.
One day in eighth grade,
The principal came into our class and demanded,
"Young lady, go into the bathroom
And wipe off all that makeup!"
I felt like two cents,
Too ashamed to tell her the truth.
My father's university was pogroms and poverty.
He belonged to a revolutionary organization
In Czarist Russia.
His brother had killed a police spy,

And my father was under surveillance,
So he married my mother for her dowry
To escape to the faraway paradise of America,
A marriage quilted of necessity, not love.
They knew no one in America.
An immigrants' organization helped them
Find a small apartment in East Harlem.
My father got a job as a metal worker.
Life was hard for both of them,
Especially my poor, bewildered mother.
Soon she had me, her first child.
My father studied English after work,
Leaving her alone day and night.
Couldn't someone from the family come live with them?
My mother, Rose, pleaded.
"How? Where will I get the money?"
Abraham Rosenfeld shouted.
Sixteen months after me, my sister, Gussie, was born.
Ill-nourished, my mother diligently nursed me, then her.
Later, my mother pushed us to compete with each other,
So we'd become smart, somebody, school teachers.
A coal stove heated our cold-water flat.
When we lacked money for coal,
My teeth chattered, my fingers froze
In spite of wearing long johns, an overcoat, and gloves.
Hunger was my constant companion.
My eyes went wild seeing food in my friends' houses.
They called me "Spaghetti" because I was so tall and thin.
Gussie, my brother, Norman, and I were frequently sick.
When Gussie had scarlet fever,
My mother lowered food for Norman and me
On a string from the third floor down to the street,
Our temporary daytime home.

I was her ambassador to the outside world
Because of her fractured English,
Traveling downtown to buy her dresses,
Wheedling extra credit from the grocer
When my father was out of work,
Bailing my brother out of trouble in school,
Although she did have a flair
For haggling with pushcart peddlers.
I was my sister's and brother's keeper,
Robbed of a childhood,
Turned into a fighter at an early age.
I didn't want to be weak like my mother
And idolized my worldly father,
The union activist and poet,
Going with him on a huge protest march for Sacco
 and Vanzetti
And to the Rand School, where famous socialists spoke.
Years later, when my mother was dying of cancer,
She told me how abusive he'd been toward her,
And sadness engulfed me.
How blind I'd been!
At Wadleigh High School,
I organized a social problems club.
Pearl, one of the members,
Spoke passionately about repression
And the need for sex education.
Well, the principal found out and had Pearl,
That dangerous agitator, expelled.
Furious, I joined the Young Communist League
And at 15 became a soapbox orator in black Harlem,
Drawing large crowds,
Demanding the landlords and the city
Clean up the rat-infested tenements.

But we weren't strong enough then, in 1927.
Meanwhile, I put on fancy clothes
And pretended to be 17
And got a job selling dresses in black Harlem.
Making $3 on Saturdays felt like a fortune.
But after a while telling large women,
"Honey, that dress looks great on you,"
Turned my stomach, so I quit.
I applied and got accepted at Hunter College,
An all-women's school.
My father had become secretary treasurer
Of the Iron and Bronze Workers Union,
And I worked several summers in his office,
Receiving a crash course in union organizing.
The atmosphere at Hunter crackled with political activity,
And I was right in the thick of it,
A gadfly in my classes,
Picketing ROTC at City College.
A face full of pimples didn't stop me
From having boyfriends.
At the Renaissance Casino in Harlem,
I used to dance with black guys.
They'd hold you so tight you could hardly breathe
To test your racial IQ.
Dancing on a dime, they called it.
I didn't mind, so I passed the test.
I loved the hot jazz and delirious dancing,
The lindy, foxtrot, shimmy and shake.
But my mother was afraid Gussie and I
Would dance all the way to the altar
With black men,
So after my father became a union official
And saved a few dollars,

We moved to the East Bronx.
I got a job at Gimbel's selling dresses.
I hated their insane quotas,
Like chains around our necks,
So two other workers and I organized a union.
When it became official, I was thrilled.
Now the workers could breathe,
Giving me hope for a more just, kind world.

Baby Carriage War

"This is my baby carriage!
I left it here this morning,"
The woman said,
Pointing to a black-hooded carriage
Flanked by several others.
"No, it's mine!" my mother insisted,
Shaking her head.
A verbal tug-of-war ensued,
Punctuated by glares, stubborn voices.
I was around seven, my sister three.
My strong mother, who knew everything,
Always knew what to do,
Would surely win,
But her adversary, face stamped with determination,
Had pulled the rope free.
Clutching the carriage handles,
She began wheeling the buggy away.
Stop her! I willed my mother,
Who just stood there,
Shoulders slumped in defeat,
Eyes blurred with silent tears.
I turned quickly away,
Frightened by her bruised nakedness,
Wishing I could beat up the woman
Who had humbled my mother
In my presence,
At the same time wondering:
Was the other woman right?
And not knowing then how extraordinary this moment was.
I would never see her cry again,
My communist mother, the political fighter,

Who'd grown up poor
And much too soon.

Collecting the Rents

The father's hard eyes
Fasten on his nine-year-old son's face.
"I'm collecting the rents today.
I want you to come with me,"
He demands.
"Yes, father."
Donald smiles.
He feels special,
Chosen over his older siblings
By his powerful father,
Who works all the time,
Makes a lot of money,
And has a ferocious temper.
They trudge through Brooklyn streets,
Entering weathered brick tenements.
In front of a scarred door,
His father gestures impatiently.
"Move over to the side, Donald."
'Why?" Searching his father's taut face.
"Sometimes they shoot through the door.
You have to be tough with these bastards,
Or they'll walk all over you."
He pounds on the door,
Calling out harshly.
Donald's knees are shaking.
He hates this sign of weakness in himself,
Hopes his father hasn't noticed,
Wants to be strong like his father,
Not some loser everyone steps on.

After the Election, 2016

(From a dream)

Dark eyes gleaming,
The wolf sniffs at my sister's crotch.
"Hey," I call out.
He pivots,
Then struts toward me,
Hard, gray flanks rippling,
Iron stare freezing my blood.
When he nips at my leg,
I feel a stinging pain,
Retreat toward the open front door.
Snarling, he pursues me.
I decide to outwit him,
Shove him out the open front door.
But he's immovable, a tank.
It looks grim.
I jerk awake,
Arms outstretched,
Only slightly relieved
To realize it's just a dream.

Postal Clerk

She leans toward me
As I approach her window,
Plain, round face
Transfigured by a beatific smile.
"How are you today?"
Like a country neighbor
Greeting me on her front porch.
"Good. And you?"
"Couldn't be better.
Thank you for your patience."
I've waited about 10 minutes.
She's the only clerk working
In this busy office.
"What can I do for you today?"
"I'd like a book of stamps."
An enthusiastic tour guide,
She points a stubby finger.
"We have farmers' market, flowers, and forever."
"I'll take the flowers."
I slide her a ten.
"Thank you for the small bill."
She hands me stamps, change, receipt.
"Twenty cents is your change.
Thank you so much for your business.
And have a wonderful day."
Is she for real?
But somehow those tired phrases
Leap and sing in her mouth.
Like a great singer,
She means every word.
"Thank you for being so pleasant,"

I reply.
"What's your secret?"
Her eyes glisten.
"Jesus," she says simply.

Trees

They never market themselves,
Post on Facebook
Or tweet on Twitter.
Yet day after day,
Like alchemists,
These majestic beings
Take in carbon dioxide
And breathe out oxygen.
Their sturdy trunks, strong roots
Are barriers to soil erosion, floods.
Leaves provide shade,
Bark valuable medicine,
Branches sweet fruits.
Communal creatures,
Inspiring role models,
Trees share water and nutrients with each
 other.
And like Jesus,
They die for our sins,
Not only for houses, furniture, paper
But the insatiable, fanged maw of profit,
Old growth forests decimated.
The trees' dignity denied.
I nominate trees for the Nobel Peace Prize.

Crippled Wings

Hoarse screams slice into my conversation
At the Berkeley café.
An icy river travels through me.
People go outside to look.
My friend John shakes his head
And we resume talking.
But the screams continue,
Hijacking my attention.
We leave shortly afterwards.
A black man is kneeling outside the café,
Muscular chest bare,
Hands bound behind him,
A white cloth covering his head.
Five somber-faced cops are standing nearby.
"I deal with this sort of thing a lot at work,"
John says matter-of-factly.
"He's psychotic.
It's good there are several cops here.
It helps prevent violence."
I nod, grateful.
Still, there's a stone burdening my heart
As I observe this faceless figure
Haunted by demons,
Brought to his knees
On unforgiving urban pavement,
Hands trapped like crippled wings.

Don't Blink

"Don't blink!"
The eye doctor's assistant demands.
My body stiffens.
"You blinked!" he chides,
As if I've just soiled my underwear.
He shakes his head.
"We'll have to do it again, sir."
This, after repeated attempts
To map my cornea.
Resignedly, I lean forward,
Press my right eye to the slot,
Will myself not to blink.
After about 20 seconds, Francisco pleads,
"Don't blink! Don't blink! Don't blink!"
But once again I succumb.
He sighs heavily.
"Sir, you are the worst patient I've ever had!"
"Sir" and "worst patient,"
Like snow in the tropics
Or an elephant marrying a cockroach.
Startled, I'm not sure
Whether to laugh or feel insulted.
Francisco paces back and forth
In his immaculate white uniform,
A frown souring his handsome,
Café au lait face,
"All right, that's enough,"
He snaps.
"Let's go check your vision."
"Should I take out my contacts?"
He gasps.

"You're wearing contacts?
We'll have to do it all over again."
I laugh helplessly.
'You didn't ask if I was wearing contacts."
He nods. "Yes, it's my fault."
His admission gives me some slim satisfaction.

After several "failures,"
Francisco concedes,
"That was the best one.
We won't have to do the left eye again."
I feel like a student who's gotten an A
On a tough final exam.

At home I feel unsettled, stewing.
Should I file a complaint?
Maybe he just had a hard day.

Several days later, the answer comes.
Francisco returns my angry phone message promptly,
Then asks, "Is there anything I could do differently
The next time?"
Touched, speechless for a moment,
I feel the knot in my chest loosening.

The Gallery

Driving in an unfamiliar part of town,
Mostly warehouses, garages,
I'm lost, start to panic,
Ask directions at a gas station.
Fruitless, so I wander about,
See an open door
With the word "Gallery"
Painted in black letters on the wall.
An art gallery. They'll help me!
It's dark inside,
But maybe it's a special exhibit.
As I enter, someone shouts,
"What the fuck are you doing,
Coming into my house?"
The words explode inside my head.
Heart hammering in my throat,
Tongue frozen.
I retreat.
Built like a barrel
Or a fire hydrant,
Eyes angry pebbles in a doughy face,
He stomps after me,
Shaking a pudgy fist.
"I'll shoot you in the head!"
I walk faster,
Refuse to run, show fear,
As death stalks me.
Reaching my car,
I finally turn around,
Prepared for him to send me
To the next world,

But he's gone.
My body begins to breathe again
As I think,
That's the strangest art gallery I've ever seen.

Following Your Bliss

(An acquaintance tells me his story)

I grew up in the Arizona desert
During the Depression,
A fish out of water.
My father strutted around,
Like a little bantam rooster.
He was a taxidermist
Who shot and skinned animals,
Then mounted them on the wall.
He thought I was a sissy.
My grandmother, my savior,
Protected me from him
And said it was OK for me
To play with dolls.
So by the fourth grade,
I was working with marionettes,
The beginning of my show business career.
My mother was one sixteenth black,
Light-skinned, passing for white.
She used to powder her face
Before going to the market.
A lot of my family were slaveholders,
And when I was growing up,
They still treated blacks like slaves.
My parents were fundamentalist Southern Baptists.
So I've been allergic to the patriarchal religions
Ever since then.
I was a transsexual at puberty,
No hair on my body,
So they gave me male hormones.

It worked.
But when I was married,
I was like the mother to our two kids,
Changing their diapers, feeding them,
And my wife took care of the finances,
The efficient businessperson.
Eventually, we grew apart and got divorced.
I taught high school for 25 years.
In Burlingame, a filthy rich place
With snooty parents,
One of my students was Bing Crosby's son.
He used to cut class to play golf.
I told him, "You either come to class every day
Or play golf. Which is it?"
He said, "I'll play golf."
"Good," I replied. "You've made the right decision,
 Following your bliss."
In Oakland I tried an experiment,
Using only sign language for a week.
Spoken language can be so limiting.
The kids loved it,
But the principal was furious.
He asked if I had a medical problem.
I shook my head.
A serious psychological problem?
Again I shook my head.
Then he said: either start talking or get fired.
I started talking.
You see, all my life I've followed my bliss,
Living in different countries,
Holland, France, Chile.
Singing and dancing in musicals,
Building sets and directing plays in high school

So black and Chicano kids
Could develop a love for the theater.
Che Guevara is my hero,
A man who followed his bliss.
I'm 86 years old
And feel 40 years younger.
I live on a boat,
Walk three or four miles every day,
And abstain from sugar,
A cancer that strips your body of nutrients.
I'm writing books on astrology and tarot,
Making new discoveries all the time.
Every day feels like heaven.

A New Life

They came for me
In the caverns of midnight,
Drumming on the door
With fists reverberating in the darkness.
My body became stone,
My tongue a dead slab.
Their entreating voices
Caused my heart to hammer
As if to burst.
When the clatter of their footsteps
Receded an eternity later,
My knees buckled
Like those of a child learning to walk.
They came for me
Like an obsessed lover,
In the stillness of early morning
And the bustle of mid-afternoon,
On the next day
And months later,
Lulling me to believe
My stubbornness had defeated them.
They came for me
Like a creditor who has forever,
On spring days that danced
And winter nights leaking rain,
Tapping once on the door
And hammering for hours
With strange promises of unconditional love.
They came for me
Like the stars and tides,
My silence a ripple

In their vast ocean,
My resistance a glacier
In their infinite furnace.

They came for me one night
In the wind and the rain,
Knocking softly,
Whispering endearments.
And exhausted with fear,
Rebellion and loneliness,
I opened the door
And invited them in.

Acknowledgments

Thank you to Richard Kempton, Mary Laird, Una Kobrin, and Victoria Sears for your generous financial support of the book.

To Bob Coates for giving me access to a large number of Dan Marlin's poems.

To Fred Kellogg and David Schooley for giving me access to many of Dan's paintings and drawings.

To my writing group, past and present: Marc Hofstadter, Richard Woodruff, Mitch Zeftel, Paul Belz, Una Kobrin, Terry Tierney, Judy Gussman, Eliza Shefler, Janell Moon, and David Schooley for helping me improve some of my poems in this book.

To Norm Millstein and Kate Clark for their stimulating poetry salons.

And especially to my wife, Naomi Rose, for all her support and hard work to make this book possible, as well as for publishing it.

Lastly, to Margaret Copeland for her excellent design and typesetting of the book.

—RALPH DRANOW

About the Authors

Ralph Dranow is an editor, ghostwriter, and writing coach as well as a poet specializing in people's stories. He has published eight poetry books including *A New Life*, one short-story collection, and numerous poems and articles in magazines and newspapers. He lives in Oakland, California with his artist/writer/musician wife, Naomi Rose; stepson, Gabriel; and cat Lucinda, embodiment of love. Ralph's website is: *www.ralphdranow.net*

Daniel Marlin (1945-2017) was a poet, artist, translator, and peace activist. He traveled extensively, spending much time in Japan, where his wife, Toshiko, was born. His book *Heart of Ardor* contains over three hundred images of his vibrant paintings and drawings, along with his commentary about his artwork. Daniel's other books include *Jerusalem and the Boardwalk*, *Amagasaki Sketchbook*, and *Isaiah at the Wall: Palestine Poems*.

Also by Ralph Dranow

A New Life: Poems (Rose Press, 2014)
Available from *www.rosepress.com* and *www.ralphdranow.net*

The 76 vivid poems in A New Life by Ralph Dranow offer us a unique and compassionate view of what it is to be human. In this collection, the old life becomes the new life through the poet's discovery of the mystery and wonder that lie just beneath the surface of our everyday lives.

<div align="center">✳</div>

"I've been slowly savoring and loving your book. I admire your courage to keep opening and exploring the depths of your own soul, and to share the vulnerabilities and strengths, uncertainties and wisdom you find. What a great gift to the world!"

—CHARLES BURACK, author, *Songs to My Beloved* and
Leaves of Light

"Although I've a very prosaic nature, not given to poetic rapture, I've been touched and inspired by Rumi and by Ralph. Both paint for me such clear and intense images that open my heart and bring a magic to the scenes of life they portray. Ralph's poetry is tender and honest and bittersweet. He shares the raw truth of human experience with us from childhood to seniority, and the word glimpses, like snapshots, of everyday experiences, are like sweetsour candy melting on the tongue. For me, Ralph's poems open the heart to embrace our shared mundane world with surprise and delight. Even when he is describing a painful moment or memory, his view is compassionate. He is a keen observer of human activity, feelings, and relationship, and his poems nestle into the heart in a genuinely comforting way."

—SHONEN BRESSLER

"I have always loved Ralph's poems, since the first day I met him at the start of this century, each of us having brought writing as a way of getting to know each other. A tall, athletic, good-looking man with shyness peeking out from his smile, he brought, for his part, a sheaf of typewritten poems and shared some with me from across the table. I hung on every word, entranced. A better introduction to the soul of Ralph Dranow I could not have had. Ralph's looking, through his poetry, changes things. It guides our hearts into unexpectedly touching territory."

—NAOMI ROSE, author, *Starting Your Book: A Guide to Navigating the Blank Page by Listening to What's Inside You.*